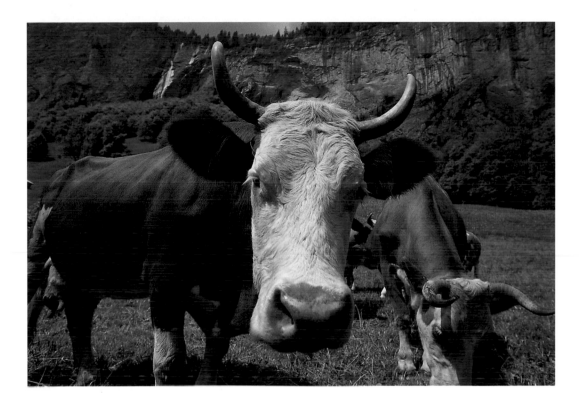

Journey through

SWITZERLAND

Photos by

Roland Gerth,

Text by

Otto Merki and Marion Voigt

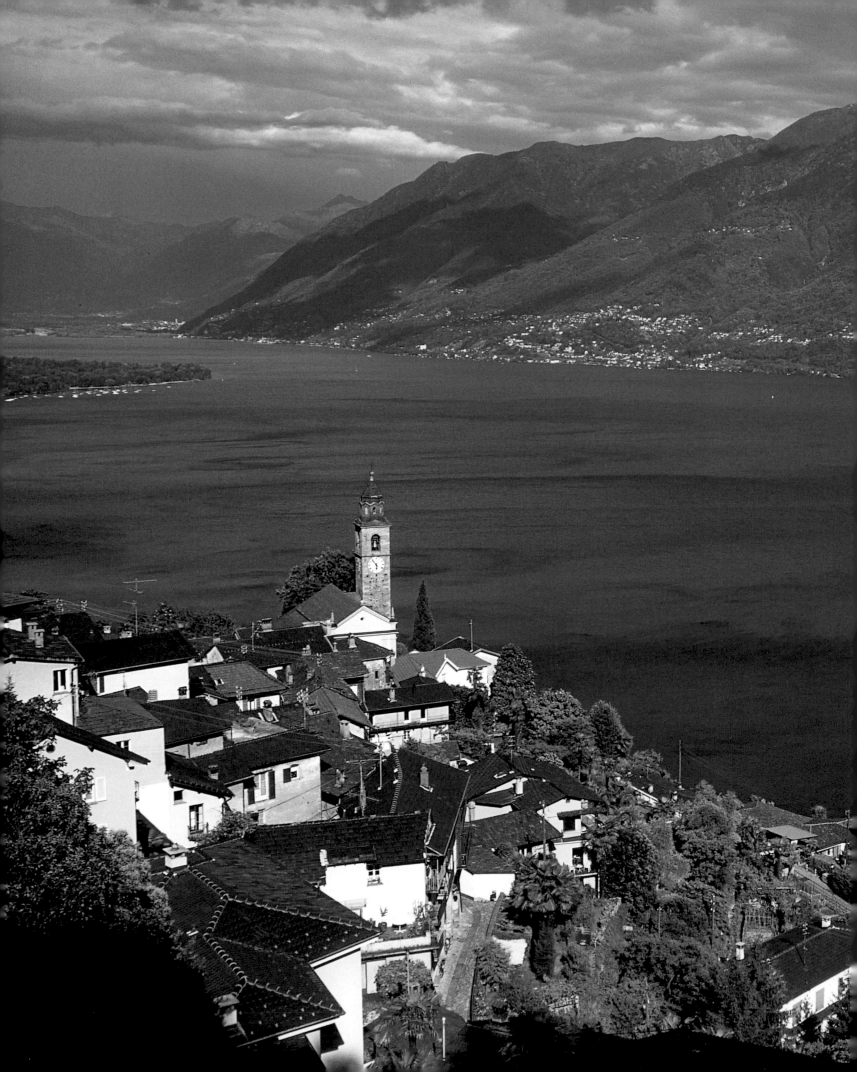

CONTENTS

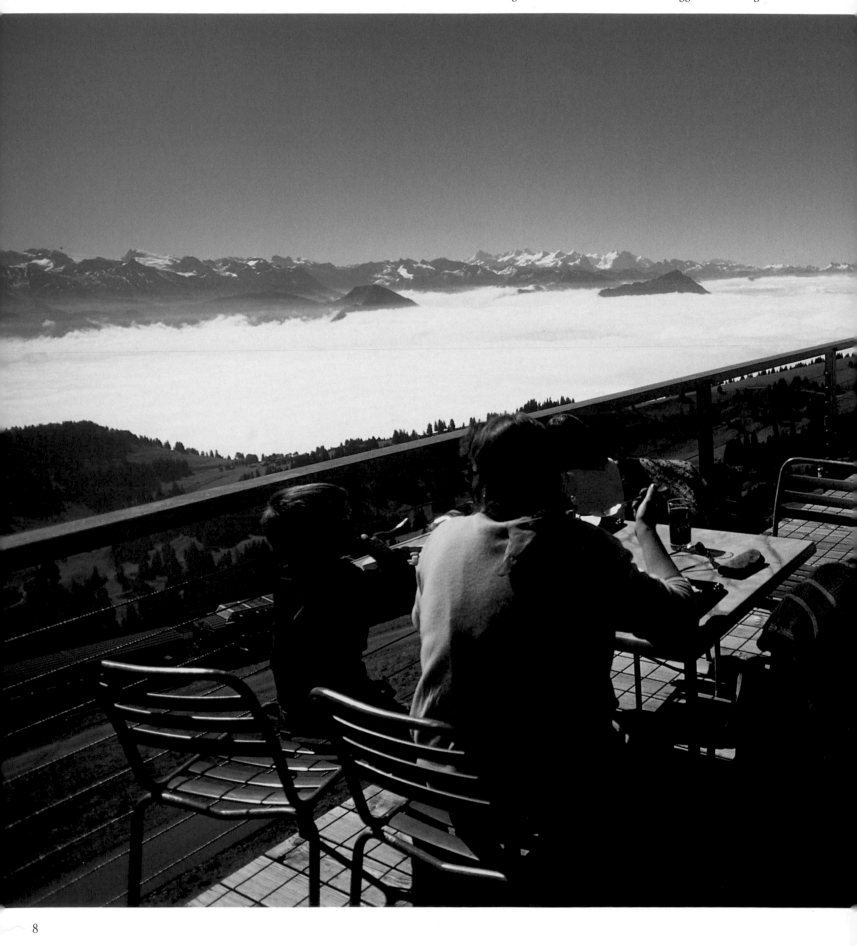

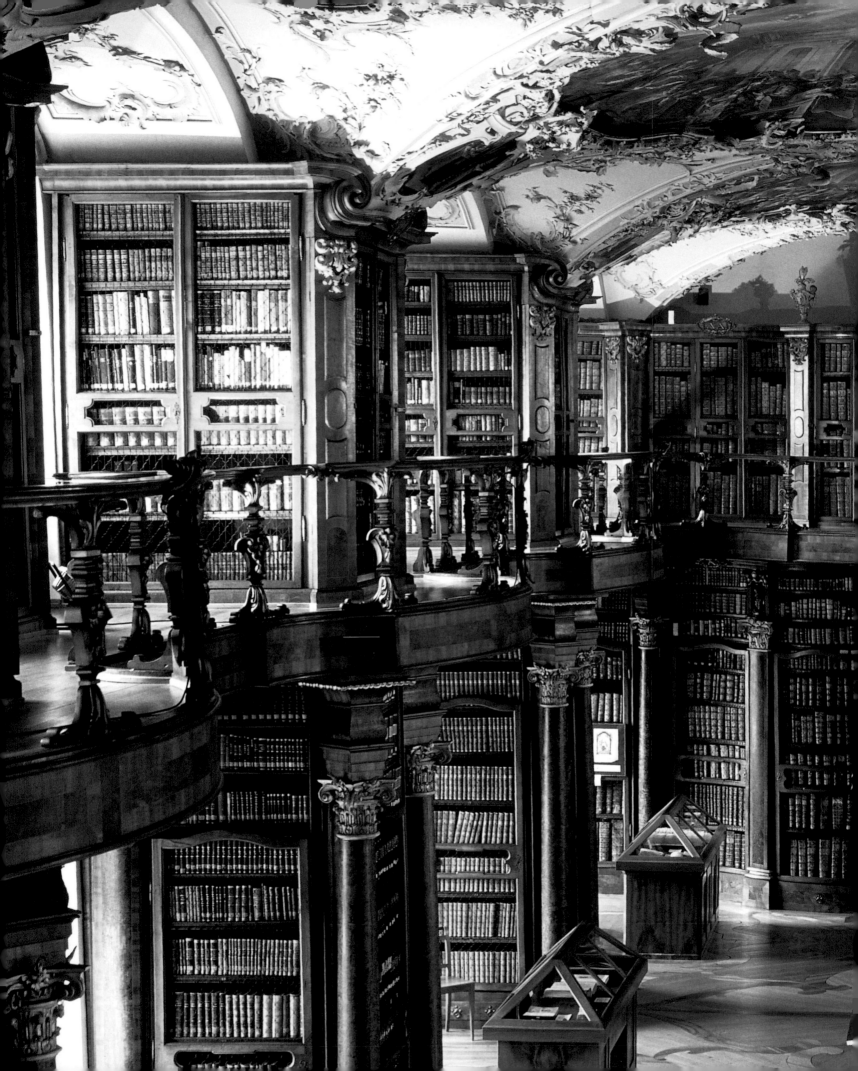

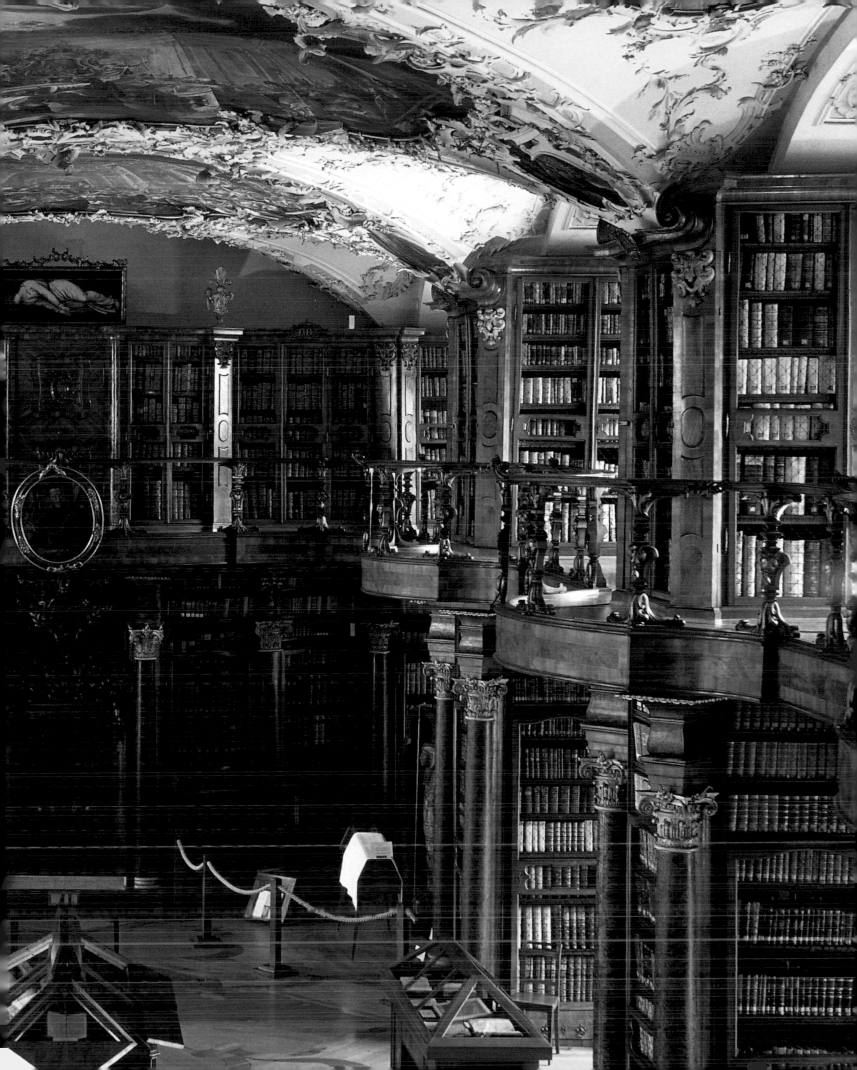

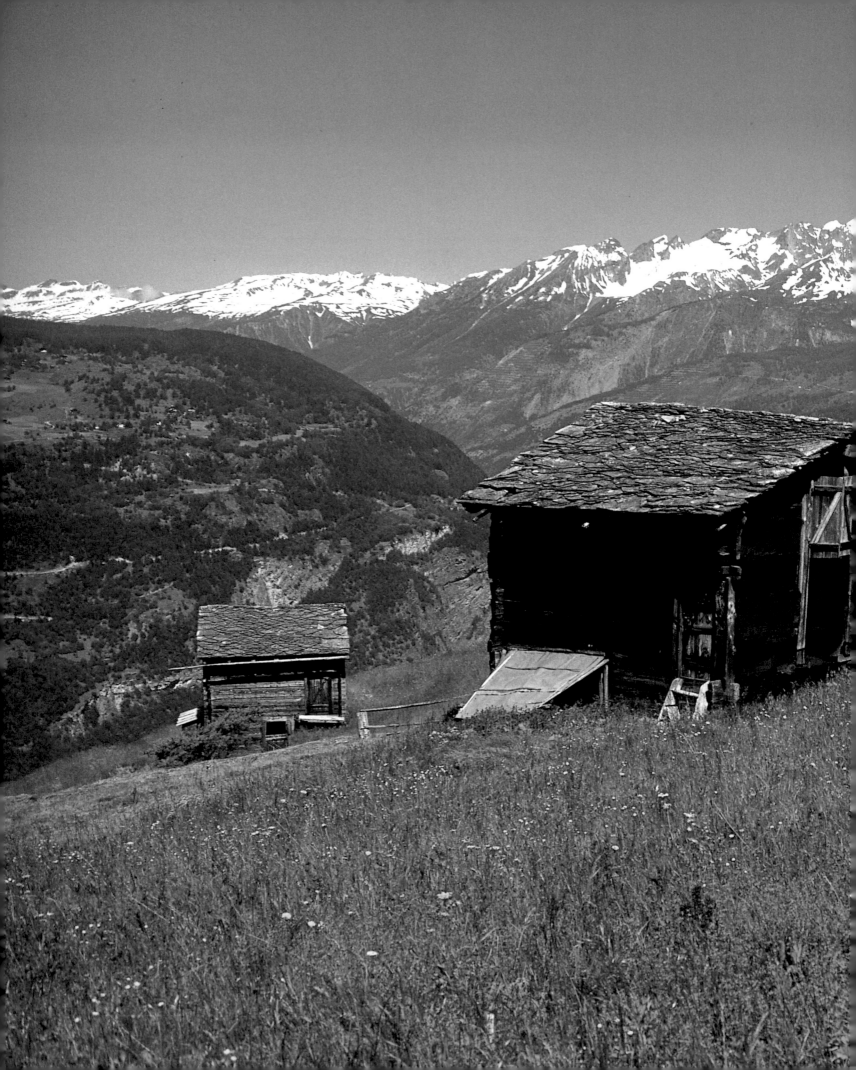

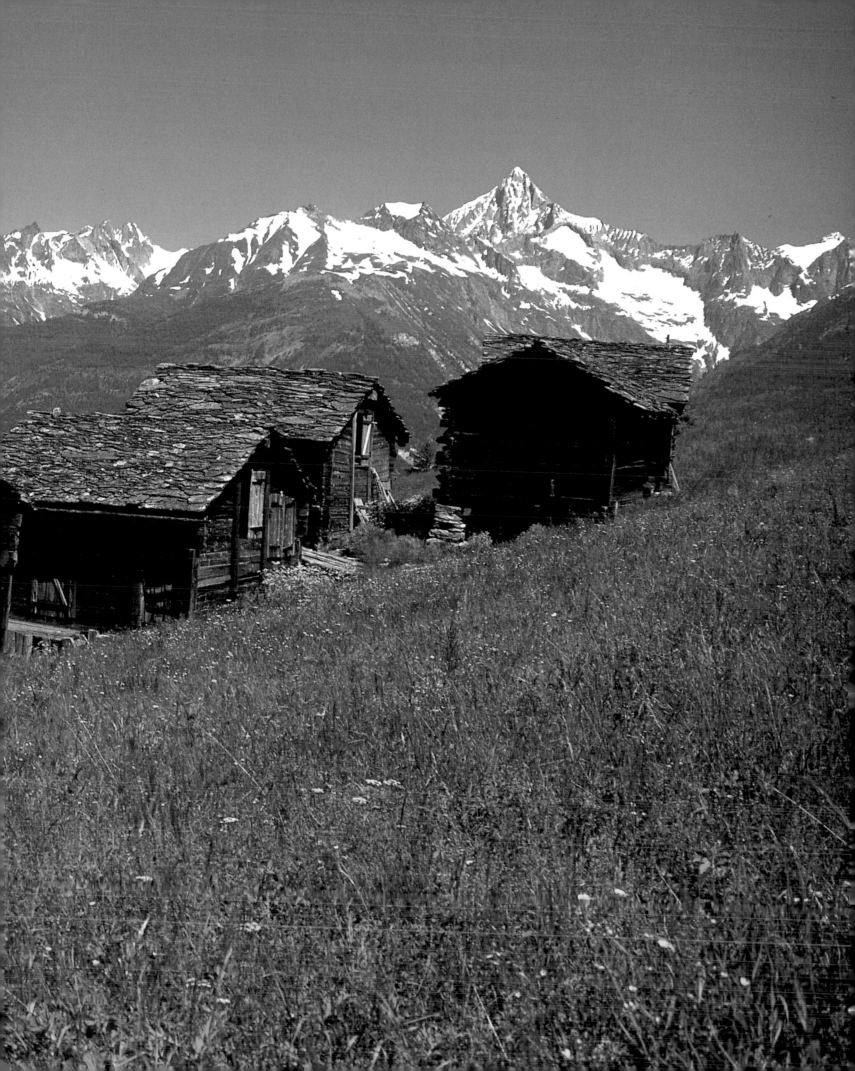

SWITZERLAND

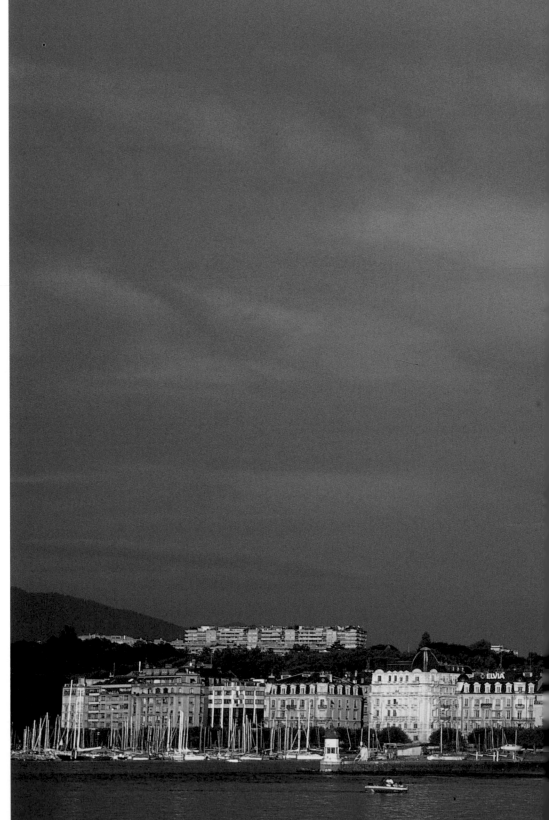

Page 12/13:
In the Valais Alps below Vispertenninen are the highest-lying vineyards in Europe at 2,300 to almost 3,940 ft (700–1,200 m). In the background, on the far side of the Rhône Valley in the Bernese Alps, sprawl the impressive glaciers around the Aletschhorn.

Against the chic backdrop of Geneva's lakeside promenade, where the Rhône flows out of Lake Geneva, the Jet d'Eau fountain shoots up 460 ft (140 m) into the air.

The people of Switzerland are widely considered to be industrious, reliable and honest, good-natured, peaceable and friendly. What they occasionally lack is a healthy dose of political correctness (there are Swiss men, Schweizer, but the female form, which would be Schweizerin, doesn't exist). As we know, clichés die hard. Not only have we just pigeonholed the Swiss themselves; when Switzerland the country is mentioned – cross your heart now – who doesn't immediately think of the Matterhorn or St Moritz? Of a land of mountains where an alpenhorn-blowing, yodelling race of goatherds lives in peaceful neutrality? Of Emmentaler and Appenzeller cheese and of chocolate which melts in your mouth? Or of those legendary Swiss bank accounts which in the »most direct of all democracies« are inviolable, even sacrosanct? In short, who would doubt that this is pretty much heaven on earth?

NOT JUST LUCK

The Swiss have grown up in a Switzerland deeply rooted in the belief that it's something very special. They take full credit for the unique beauty of their countryside – the snow-capped mountains, the majestic glaciers, the striking lakes and river valleys and the ranges of rolling hills – and are proud of it. The fact that Switzerland was spared in Europe's last wars is, like its scenery, not just luck; the Swiss consider it a major achievement that they managed to stay out of the war, thanks to an army whose myth lives on in the minds of many, even though moves have been made to disband it. The military remains a ritual both national and masculine – despite the fact that women are allowed into its ranks.

– HEAVEN ON EARTH

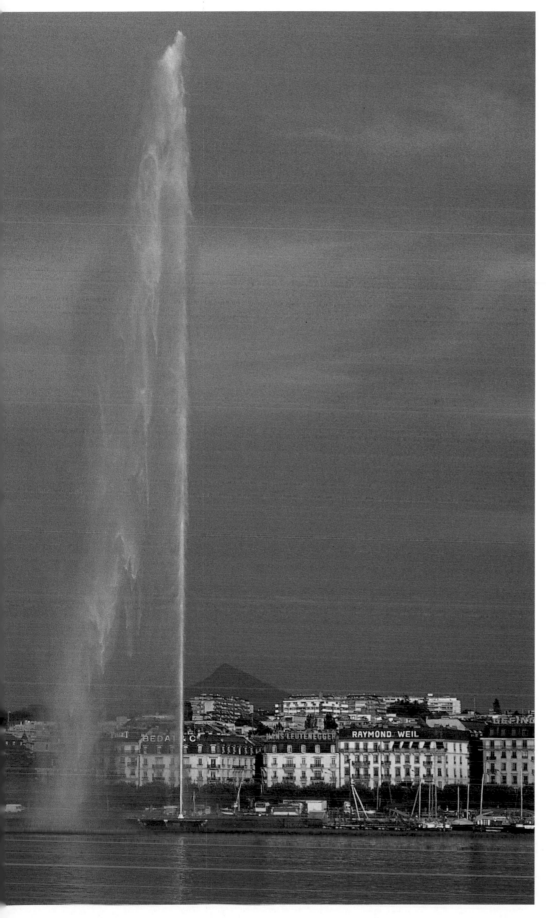

What also makes Switzerland special is its frequently praised ethnic mix, the peaceful coexistence of several linguistic, religious and cultural groups. Cohabiting with neighbours whose language and interests are often very different from your own is not, however, always a harmonious affair. The disproportionate number of German Swiss (70%) to French Swiss (ca. 20%), Italian Swiss (5%) and a tiny group of Romansch-speakers (1%) is the stuff conflicts are made of. A sporting antagonism is also evident between the largely Catholic and Protestant regions, between the conservative country cantons and the areas dominated by the larger cities, where today three quarters of the population live. To this add the fact that a sixth of Switzerland's seven million inhabitants are not actually Swiss. Action groups campaigning against »foreign infiltration« are not the only sign that the integration process isn't often as smooth as one would wish.

THE MYTH OF THE SWISS FIGHT FOR FREEDOM

»We are the land of freedom and together with Schiller and our non-nationals absolutely convinced that we fought for freedom through revolution.
This is not true.«
Peter Bichsel, ›Des Schweizers Schweiz‹
(›Switzerland of the Swiss‹)

The Swiss have their national myth and their »William Tell« from none other than Friedrich Schiller. Once upon a time, the original three forest cantons of Uri, Schwyz and Unterwalden formed a secret alliance, swearing to fight for independence from the Habsburgs. In order to test the loyalty of his peasant underlings, the local Habsburg governor, Gessler, had a hat placed on a pole on the market place in Altdorf to which all who passed should bow in respect. When William Tell refused to do so, he was arrested and in punishment made to shoot an apple off his son's head with a bow and arrow. Against all odds, he succeeded. Yet for being in possession of a second arrow Tell had intended for his tormentor, should his son have been injured, the rebellious marksman was to be thrown into the dungeons near Küssnacht on the other side of Lake Lucerne. On his way there a föhn wind blew up on the lake. Tell, who had been handed the ruder, steered

the boat towards the shore and suddenly leapt to safety on a rock, pushing the boat back into the churning waves. The next day he lay in wait for Gessler near Küssnacht. When his second arrow finally struck its target, it did so with the same Swiss precision as the first.

Switzerland's archetypal tale of freedom is first recorded in the »White Book of Sarnen« (1470). To what extent the fable surrounding the origin of the Swiss Confederation actually corresponds to historical fact – if at all – remains to be seen. True or not, the legend is still very much alive in Switzerland. And it's not just the foreign visitors who hope to recapture some of the magic of William Tell; the Rütliwiese above Lake Lucerne, the Tellskapelle, whose frescos depict scenes from the life of the hero himself, the monument in Altdorf and the sunken lane of Tell's ambush outside Küssnacht are also popular with schools, shooting clubs and wedding parties.

FROM ANCIENT CONFEDERATION TO MODERN FEDERAL STATE

The fact that the earliest evidence of human settlement in Switzerland goes back to the Palaeolithic Age is not something which bothers the Swiss much. For them, history starts with the founding of the holy alliance in 1291.

When at the end of the 13th century Switzerland began gradually releasing itself from the clutches of the House of Habsburg, partners were needed to join the new alliance. Avidly pursuing a policy of expansionism, the original Confederatio Helvetica slowly expanded to include 13 towns and their affiliated territories and villages. The confederates earned themselves a reputation as courageous warriors through glorious victories over the Habsburg army at Morgarten, Sempach and Näfels and over Charles the Bold, the duke of Burgundy, at Grandson, Murten and Nancy. Yet it wasn't until the Humanist movement took root in Switzerland, when Basle became a significant university town and centre of printing, that efforts were made to develop an overall Swiss consciousness. In the first religious war between Protestants and Catholics, the life of Zürich reformer Ulrich Zwingli was claimed in the battle at Kappel in 1531. Much more

blood was shed before the two factions could agree to settle their differences. The Thirty Years' War, however, barely touched the Confederation. It had since declared armed neutrality through its Swiss military order. Yet despite its refusal to fight as a nation, Switzerland's independence from the Holy Roman Empire was only finally recognised under international law at the Treaty of Westphalia in 1648. Two hundred years were to pass before the modern federal state was born. The federal constitution for the »protection of the rights and liberties of all confederates and the promotion of their mutual welfare« wasn't passed nor the first federal assembly held until 1 November 1848.

ENTER THE MODERN AGE

Industrialisation rapidly changed the economic and social structure of Switzerland. A network of railways brought the country closer together. Engineer Louis Favre finally conquered the mighty St Gotthard with a tunnel which was to become the primary transit link between Germany and Italy. While the First World War raged in neighbouring countries, in Switzerland industry boomed. Conditions at home, especially for the working class, were, however, far from idyllic, as the first (and to date only!) general strike in 1918 documents. Almost a hundred thousand soldiers and policemen were called in to deal with the demonstrators. The strike was ended and proved successful; the 48-hour week and proportional representation for National Council elections were subsequently introduced.

The Swiss also managed to side-step the conflicts of the Second World War. The national exhibition in Zürich in 1939 expressed the need for intellectual resistance, with the Réduit, a planned retreat into the Alps which would be defended to the last man, advocating a decidedly military form of opposition. The darker chapters in Switzerland's more recent history have only been stripped of their taboos peu à peu – and notated in literary form by authors such as Max Frisch, Niklaus Meienberg and Walter Kauer. The Réduit plan, Switzerland's refusal

17

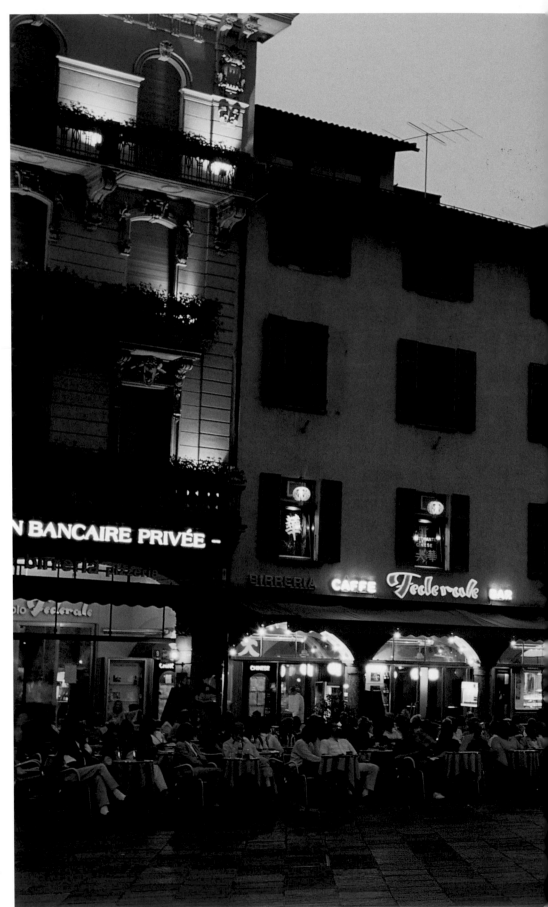

With its temperate climes, Lugano has always been a popular place to unwind. In the busy street cafés on Piazza della Riforma you can sit back and soak up the Mediterranean atmosphere of this ancient Lombardian spa.

to accommodate Jewish refugees, its trade in and trafficking of arms are just a few of the topics Switzerland is still having to deal with a good half a century on.

SWITZERLAND STARTS AT THE GOTTHARD

»The Swiss must always start at the Gotthard; it is the beginning and the end of their geography« is what we can read from Heinrich Federer. »All around you, to the right, to the left, above you and below you, you can hear water making music.« From the 12th century on the St Gotthard Pass gradually grew in importance, providing the Alps with an important trade route which forged a link between different peoples and cultures.

Transit through the Alps has been a headache for the Swiss since the Middle Ages. The rushing waters of the Reuss through the Schöllenen Gorge, for example, proved so impossible to cross that the people of Uri saw no alternative but to make a pact with the Devil. While it was dark, he built a stone bridge spanning the gorge, eliciting cries of amazement the next morning. Now the mountain folk had to keep their side of the bargain. The first person to cross the bridge was to be claimed by the Prince of Darkness. After a little thought, the canton's highest official sent a boisterous billy goat trotting over to the other side. The Devil was incensed. Lifting a giant boulder, he was about to destroy his construction when a brave old lady went up to him and made the sign of the cross over his head. Shamed, he turned forked tail and sank back down into the fiery depths.

The legend is today marked by a satanic rock (the Teufelsstein) and an image of the Devil tattooed onto the mountainside. His help was not required when from 1872–1882 a railway tunnel was built through the Gotthard, yet conditions were still akin to those of his abode. A monument at Airolo pays tribute to the victims who worked on the monumental structure. Around a hundred years later a road tunnel was blasted rather more easily through the mountain, through which thousands of cars pass each day.

RIVERS TO PARADISE

The Gotthard Massif sends water running in all directions down to the lakes and seas of Europe. To the east, the infant Rhine gurgles along its bed of scree, flanked by proud peaks, to the town of Ilanz. Here a fully-fledged river, it turns north not far from Chur, the oldest city in Switzerland, and flows tamely past vineyards and fields, its course bridled by man, past the Säntis and Alpstein ranges into Lake Constance. A stone's throw away are the gentle hills of the Appenzellerland with their secluded, spruce farmsteads and historic St Gallen, which grew up around one of the earliest monasteries of the Christian world. The Rhine, now mixed with the waters of the lake, laps against the shores of floral Mainau Island. It exits the Swabian Sea at its westernmost point and splashes past beautiful little towns, the fairest of them all Stein am Rhein with its colourful façades. In Schaffhausen it greets majestic Munot Castle before churning and frothing into the deep at Rhine Falls, eventually leaving Switzerland at Basle.

Slightly more theatrical are the upper reaches of the Rhône. The tributaries trickle out of the Rhône glacier and carve their way down the mountainside to the river bed ingesting the brooks and creeks from the off-lying valleys. The Rhône Valley widens into a fertile garden cultivated by a tough breed of mountain folk. The sunny shores of Lake Geneva are not far, with its wine villages dotted lazily about the vineyards, with its splendid castle of Chillon, with its delightful little towns and magnificent villas. In Geneva itself the Rhône leaves the lake, flowing through a decidedly cosmopolitan city where the UN has its European headquarters and scientists perform nuclear research at CERN. This is where Farel and Calvin once preached Reformation, where Rousseau was born and where Geneva businessman Henri Dunant dedicated his life to the founding of the Red Cross. To the north the River Reuss crashes down into the valley and after a short stretch peacefully enters the waters of Lake Lucerne, as calm as a millpond when there's no föhn wind to whip it into a frenzy. Old-fashioned steamers chug across the glittering surface, taking their passengers back in time. The scenery, crowned by the majestic Rigi and the fabled Mount Pilatus, is sublime. In idyllic Lucerne, described by Victor Hugo as »the wonder of Switzerland«, the Reuss flows out of the lake. At Windisch, the old Roman city of Vindonissa, it joins the Aare which crosses

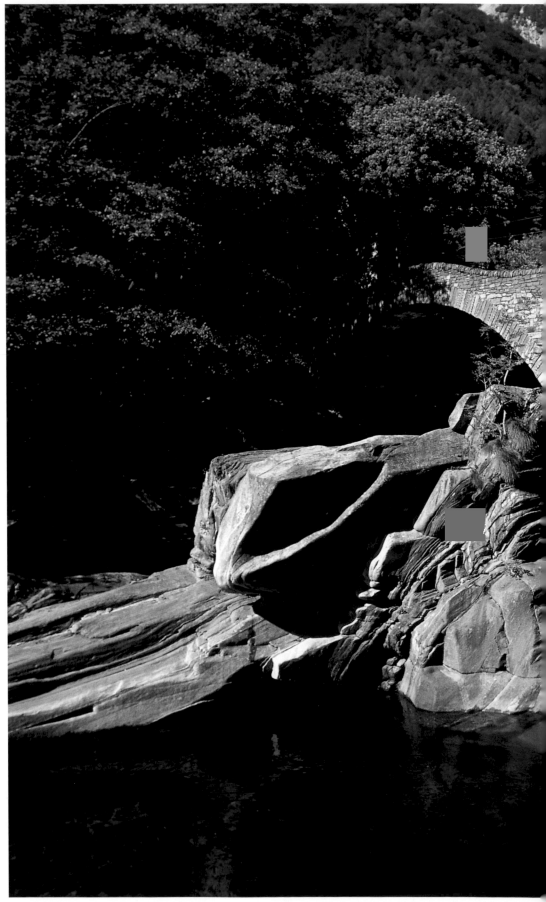

half of Switzerland, running through narrow ravines, through the tors of the Bernese Oberland, through the Swiss Mittelland and past the Jura Mountains.

From Airolo the Ticino River tumbles down south past Bellinzona with its castles to the canton of the same name, where the historic St Gotthard, Nufenen, Lukmanier and San Bernardino passes merge. Sunsoaked slopes above Locarno and Ascona await, surmounted by the Madonna del Sasso church gazing far out across Lake Maggiore. In spring the lake shores are smothered in a carpet of blossoms, where in the north only the crocuses are in flower. Everything seems milder here, even the wild valleys of the Verzasca and the Maggia, oozing a charm which is distinctly southern. The Brissago Islands, with almost two thousand species of Mediterranean and subtropical plant, have a touch of exoticness, the work of a Russian countess. She had the islands built and transformed into a unique botanical garden at the turn of the 19th century, an undertaking which left her penniless.

When dense autumn fog shrouds the Swiss Mittelland in a numbing blanket, sun worshippers can still meander along the lakeside promenades and through the winding streets of Lugano, sail over to the fishing village of Gandria and cast a final, wistful eye over paradise from Ticino's San Salvatore.

CULTURAL MELTING POT

The cultural variety of this tiny country is the subject of admiration well beyond its national boundaries, as the work of famous writers and artists, such as Gottfried Keller, Max Frisch and Friedrich Dürrenmatt, Ferdinand Hodler and Max Bill, and of architects Le Corbusier and Mario Botta substantiates. Yet where the cultural differences are most obvious is in Switzerland's architecture. The diverse climates and available building materials have produced a palette of housing with regional variations specific to Ticino, Goms, the Engadine, Aargau and Romansch areas. With great fervour, the impressive open-air museum of Ballenberg ob Brienz comprehensively documents how people used to live in the Swiss countryside.

The entire country is also spattered with palaces and castles which cling to lofty peaks, precipitous inclines and the shores of

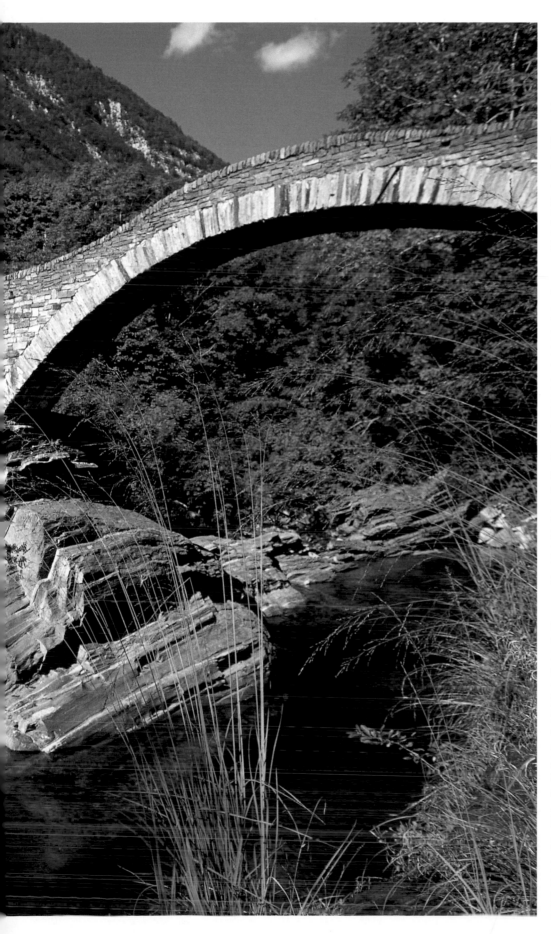

Page 22/23:
The Aletsch Glacier,
the biggest névé in the
Alps, spreads out
15 miles (25 km) between
the Jungfrau region and

Aletsch Forest. This
ancient river of ice, with
its enormous crevasses,
cracks and crags, is in
places over 2,600 ft
(800 m) thick.

lakes. Many line the ancient trade routes which zigzag through the Alps and the Jura, and in the French-speaking areas of Switzerland they seem to dwarf almost every second village, a legacy of the counts and dukes of Savoy. They are scarcer, however, in the original forest cantons, where would-be foreign potentates were driven out and the strongholds laid to waste early on in the Confederation's history.

Switzerland's position at the crossroads of Europe is nowhere more manifest than in its ecclesiastical architecture. Whereas the noteworthy Romanesque churches of Romainmôtier and Payerne are modelled on Benedictine Cluny, Carolingian Müstair attributed to Charlemagne at the easternmost point of Graubünden betrays very different influences. Where the Church of All Saints in Schaffhausen follows the Hirsau tradition, in Ticino the work of Italian masters is as unmistakable as the domination of the French Gothic in Lausanne. The German-speaking areas of Switzerland have been infiltrated by a number of different building styles. In the pilgrimage church of Einsiedeln, for example, one of the most beautiful baroque complexes in Europe, the Asam brothers from Munich painted the ceiling frescos, yet the plans for the courtyard were drawn up by an architect from Milan.

A journey to Switzerland wouldn't be complete without a visit to the many smart towns and cities which evolved during the Middle Ages and took on their bourgeois character during the golden age of the craftsmen's guilds. The architectural diversity is impressive; Appenzell of the peasant baroque is a medley of painted wooden houses with ornate oriels, barely two hours from Zürich's chic Bahnhofstraße, lakeside promenade Limmatquai and two minsters, forming an ensemble which looks like something out of an art history catalogue from the Middle Ages to the present day. There are also the delights of Bern, Fribourg and Murten, Basle, Pruntrut and Solothurn, Biel, Neuchâtel and Yverdon, Zug and Lucerne, Bellinzona and Lugano, Lausanne and Geneva to behold – to name but a few. Make haste, then, and away to pack your bags! Switzerland bids you a hearty welcome.

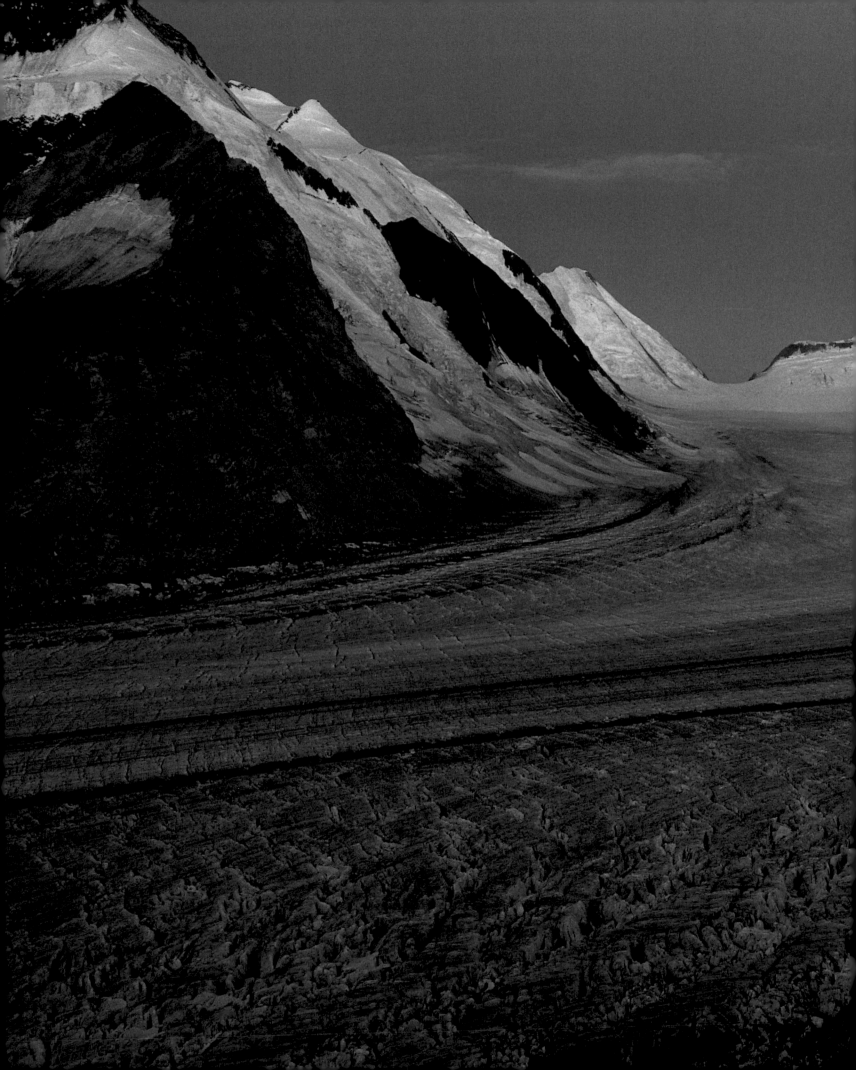

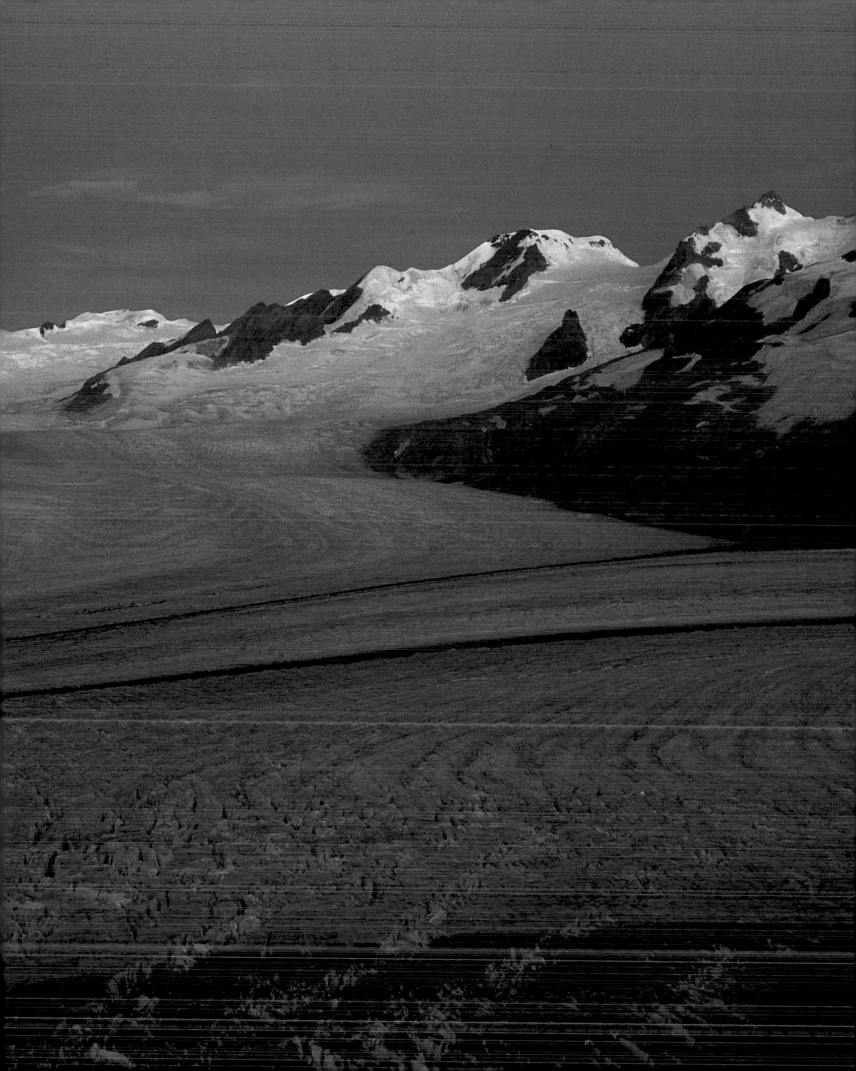

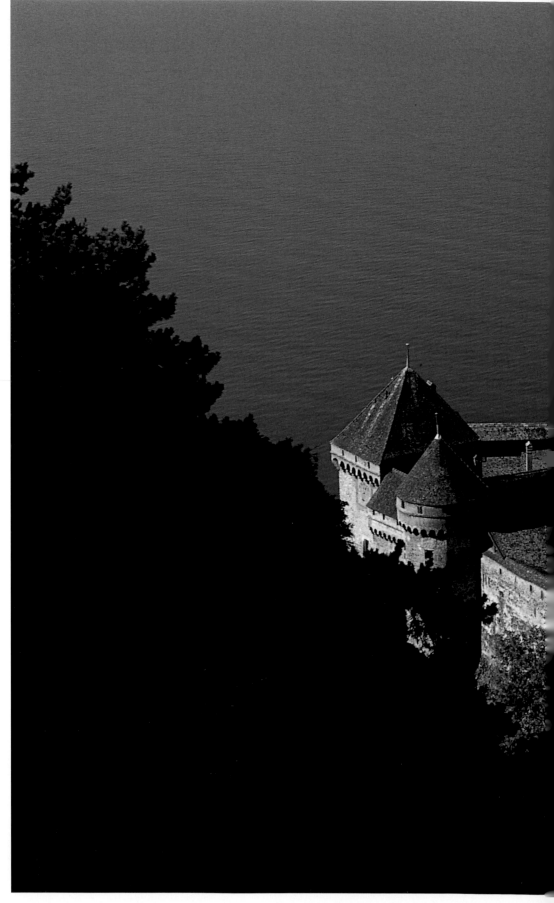

Perched on an island of rock near Montreux at the eastern end of Lake Geneva, the oldest parts of Château Chillon go back to the 9th and 10th centuries. The castle took on its present form under the counts of Savoy in the 12th and 13th centuries.

There are several canton boundaries, indeed there are worlds between chic, Calvinist Geneva, the old Catholic Zähringer city of Fribourg and the mountaineering El Dorado of Zermatt. Within Switzerland the cantons bordering on France, which only joined the Confederation at the beginning of the 19th century, enjoy special status. For centuries, large areas of western Switzerland belonged to Burgundy and to Savoy, meaning that French has survived here as the country's second language after German. The linguistic barrier runs south, straight through the middle of Valais, sprawled out between Lake Geneva and the Rhône glacier.

The lake whose French name, Lac Léman, originates from the legendary Roman hero Lemanus, contains twice as much water as Lake Constance and is entered and exited by the Rhône. The upper reaches of this river have carved a long valley (80 miles/130 km) between the Bernese and Valais Alps, which downstream at Martigny forms a wide waterway, of great historical importance, running east-west. From Martigny the Aosta Valley can be reached via the Great St Bernhard Pass; further east, from the ancient intersection of Brig, the Simplon Pass leads down into Piedmont, the Furka to the Gotthard, the Grimsel to the Bernese Oberland and the Nufenen into Ticino. In the 13th century, mountain farmers began moving away from Alemannic Upper Valais to the southerly and easterly valleys. They went to Graubünden, Vorarlberg and into the Vinschgau, founding entire Valais colonies in the mountains where they enjoyed relative freedom, bred cattle and ran dairies. Their name comes from the Latin for »valley« (vallis) and is not related to that of the first Celtoroman settlers here (the Welschen or French-Swiss).

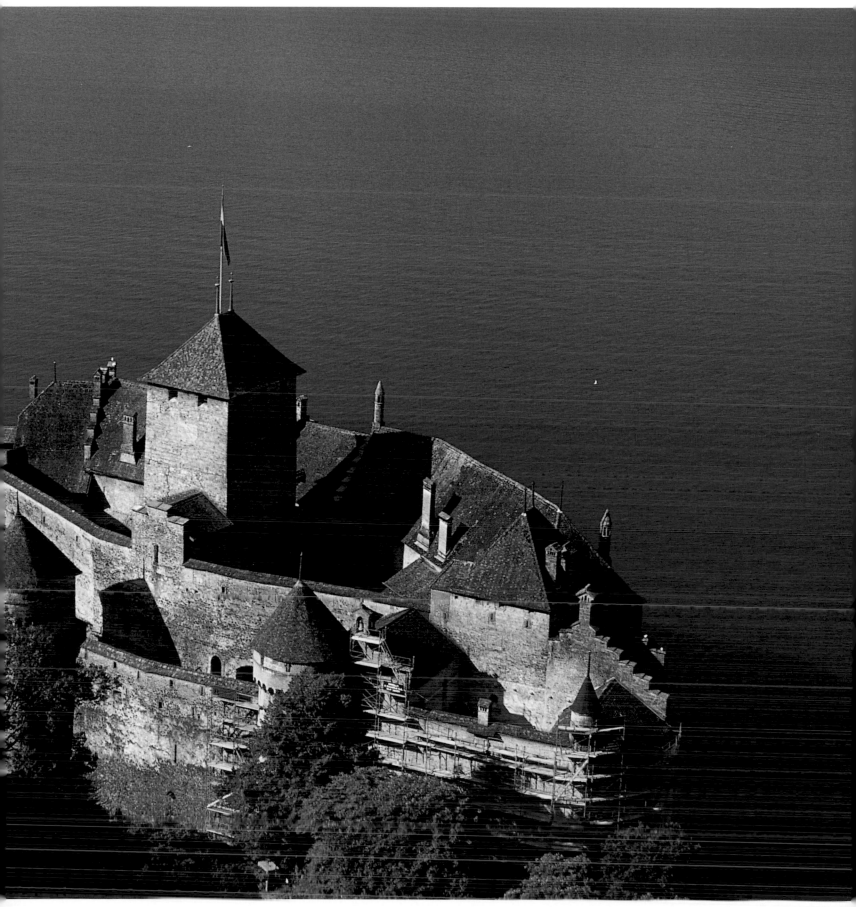

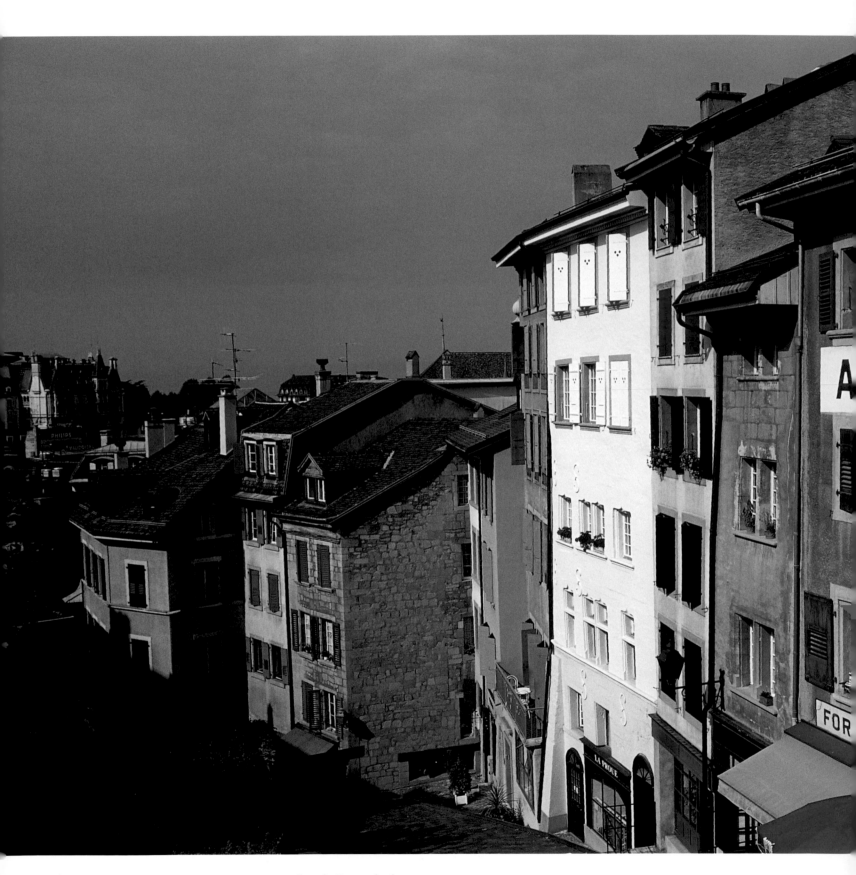

Above:
In the cité of Lausanne, up above Lake Geneva, elegant town houses line steep narrow streets and flights of stone steps which lead down to the lake and the ruins of the Roman harbour Lousanna.

Below:
Château St Marie, built
for the bishop between
1397 and 1431, watches
over the city from the
northern end of
Lausanne's old town.

In front of this imposing
edifice of sandstone and
brick stands a statue of
Major Davel from 1898.
The castle is now used
by the canton govern-
ment of Vaud.

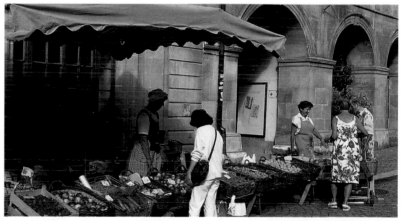

Above:
Château St Marie, built
for the bishop between
1397 and 1431, watches
over the city from the
northern end of
Lausanne's old town.
In front of this imposing
edifice of sandstone

and brick stands a
statue of Major Davel
from 1898. The castle is
now used by the canton
government of Vaud.

Above centre:
The market
on Wednesdays and
Saturdays, here flanking
the arcades of the town
hall, brings a splash of
colour to Place de la
Palud in the vieille ville
of Lausanne.

Right:
Halfway between Lausanne and Fribourg, stop off at the Savoyard town of Romont to stretch your legs along its pleasant streets and admire the exhibits in its stained glass museum.

Below:
South of Lausanne is the suburb of Ouchy, an old fishing village, whose yachting and motor boat harbour is not always as serene as it looks here.

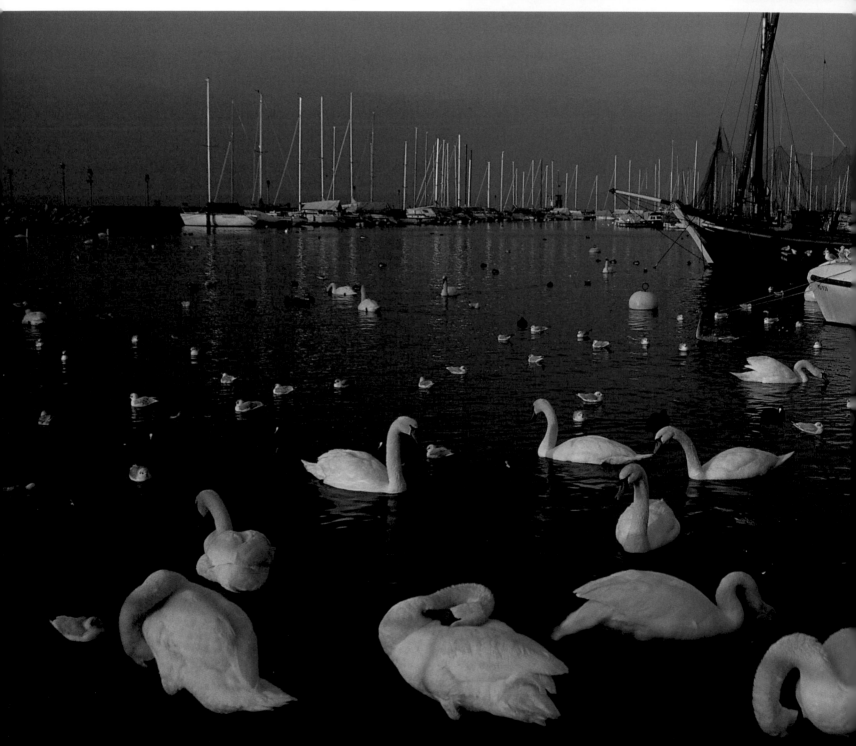

Left:
Sunny Montreux on the eastern shores of Lake Geneva on the Swiss Riviera has long been a chic spa, its success reflected in its prestigious architecture.

Below:
The Hotel Beau-Rivage Palace, erected between 1851 and 1861, hosted the Conference of Lausanne in 1932, at which the question of reparations payable by Germany to France for the First World War was finally settled.

Below centre:
The vineyards of Lavaux surrounding the picturesque wine village of St Saphorin near Vevey produce excellent white wines which can be tasted in the village's cellars and inns.

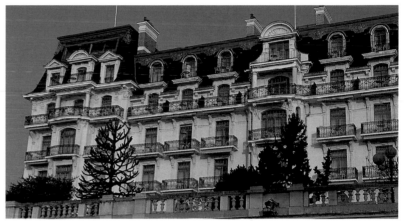

Above:
The lakeside road north of the biggest lake on the edge of the Alps, which in places is over 1,000 ft (310 m) deep, winds through Allaman and the vineyards of La Côte.

TIME IS MONEY:

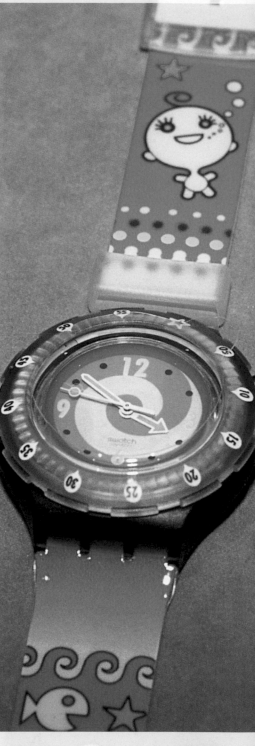

When Swatch was introduced to the market in 1983, ETA SA in Grenchen in Solothurn envisaged people buying the watch as a second timepiece, acquiring both a Swiss quality product and a fashion article. The name Swatch (Swiss Watch and Second Watch) incorporates both ideas.

Horology is still a major pillar of the Swiss economy, with little else which symbolises prosperity, quality, precision and innovation as perfectly as the Swiss watch.

In Geneva, where the largest medieval guild was that of the jewellers, lie the origins of the Swiss art of timepiece manufacture, which go back long before Geneva joined the Confederation in 1814. In the mid-16th century, after Reformer Calvin had considerably curbed the use of gold and precious stones, many jewellers turned their hand to clockmaking, soon forming the first guild devoted to their craft. Three of the known chronometer creators of this period are Martin Duboule (1583–1639), Jean Rousseau (1606–84) and Pierre Duhamel (1630–1686).

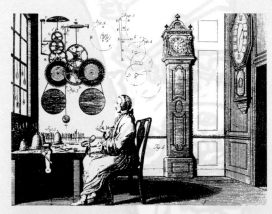

This copper engraving from 1748 shows a clockmaker in his workshop. In the mid-18th century precision timepieces underwent a crucial stage in their development with the introduction of the time-keeper for the wall as an alternative to the bulky grandfather clock.

In the canton of Neuchâtel, former goldsmith Daniel Jeanrichard (1665–1741) became something of a pioneer in the timepiece industry. He moved to Le Locle in 1705, set up a workshop and laid the foun-

dations for an enterprise based on the division of labour, sending components to be made by homeworkers which he then assembled at his workshop. By the beginning of the 18th century, Le Locle and neighbouring La Chaux-de-Fonds could boast a booming cottage industry in clocks. Famous examples of the many time-keeping devices manufactured here are the Neuchâtel pendulums modelled on French Louis Quinze clocks, which gained a distinction of their very own under masters such as Pierre Jaquet-Droz (1721–1790). Together with his son, Henry-Louis (1752–1791), and Jean Frédéric Leschot (1746–1824), Jaquet-Droz also produced musical pendulum clocks and clockwork figures.

Once Nuremberg locksmith Peter Henlein had begun building »portable clocks« at the opening of the 16th century, once Christian Huygens had introduced the pendulum as a method of keeping regular time in 1657 and the balance wheel was discovered in 1674, the way was paved for the invention of the pocket watch. Between 1760 and 1770 in Le Locle, Abraham Louis Perrelet fabricated what must have been the first automatic pocket watches. From 1815 on, elegant, flat timepieces of exceptional quality were being manufactured, with Geneva the centre of production, by horologers such as Courvoisier and Jean François Bautte (1772–1845). 1819 marked the foundation of the Vacheron and Constantin company, an employee of whom devised the angle of traction in 1825, thus solving the problem of lever escapement. Georges Auguste Leschot went into mass production in 1835, organising the entire manufacturing process with the aid of precision machines, templates and gauges. By around 1850, this development had secured the Swiss watch-and-clock industry a place as the international leaders in their field.

In 1845, also in Geneva, Polish Count Anton von Patek and watchmaker Adrien

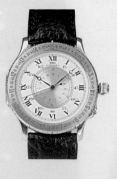

Following Charles Lindbergh's flight across the Atlantic in 1927, in 1931 Longines presented their first hour angle watch, developed together with the pioneer aviator, which made navigation much easier. The Lindbergh collection also includes this elegant Quartz model.

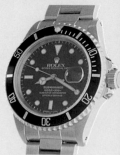

The COSC-approved Rolex Submariner is a chronometer which has been tested at various depths and temperatures to ensure its absolute accuracy.

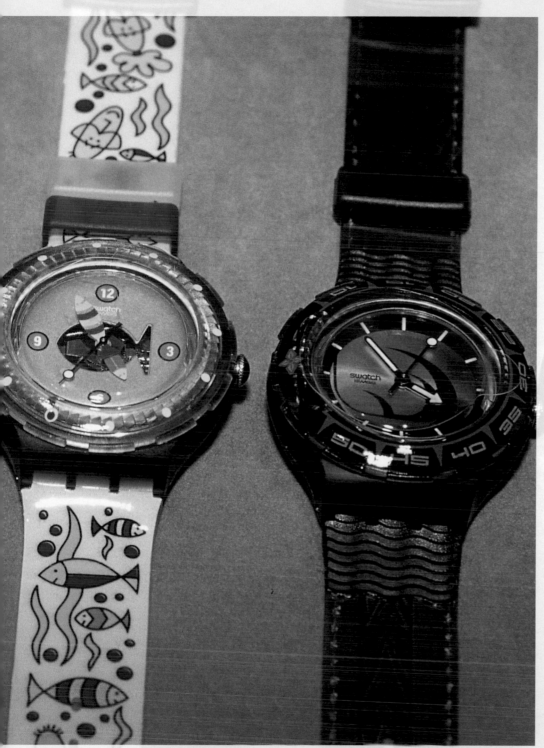

Philippe, who conceived the winding button in 1872, opened Patek Philippe. Besides Geneva, Le Locle and La Chaux-de-Fonds, which was where car manufacturer Louis Chevrolet and architect Le Corbusier were born, the annals of other Swiss towns also contain the names of famous horologists. Basle has the Dicbolder (16th/17th centuries) and Enderlin (17th–19th centuries) families and master clockmaker Nicolas Fatio (1664–1753), Bern Balthasar Blaser (18th century), Winterthur the Liechti family (since the 16th century) and Zürich the Bachofens (between 1660 and 1788).

Biel also evolved into a centre for the timepiece trade after numerous watchmaker families were draw to the town from the French Jura in the second half of the 19th century by tax privileges. Among them were the Brandt brothers, founders of Omega. In c. 1870, the first wristwatches to be produced on any large scale appeared. Demands from ladies and the military for practical horologes hastened the advance of the watch. Despite complaints of sloppy precision, which were voiced well into the 1920s, general acceptance of the wristwatch grew and by 1935 the »personal clock« had seized 65% of the market. Milestones in the career of the watch are the waterproof Rolex Oyster (1926) and the first practicable automatic wristwatch (Perpetual), built a few years later by Hans Wilsdorf from Kulmbach (1881–1960), who in 1920 launched Montres Rolex S.A. in Geneva.

Fine-sounding names and makes have been the mark of the Swiss watch since the Second World War. The structural crisis of the 1970s, one of the causes of which was the flood of imported Quartz products, triggered innovative developments in the world of the timepiece, with Swatch (1983) among them. Over the last few years, even mechanical watches with extremely complex works, the majority made in the Vallée de Joux in the west of the country, have experienced a renaissance.

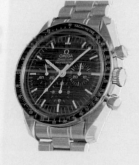

Neill Armstrong leapt out onto the moon in 1969 with a Speedmaster Professional on his wrist. Omega's Moonwatch was chosen by NASA as the official astronaut watch for its reliability even under the most extreme conditions.

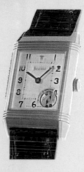

The valuable Reverso Répétition Minutes by Jaeger Le-Coultre can sound the hours, quarter hours and minutes, for which 306 individual components are required, each one painstakingly worked by hand. The casing, developed in 1931, is reversible.

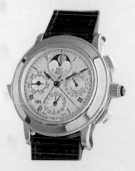

The International Watch Company (IWC) in Schaffhausen has produced a number of outstanding horologes, among them the Destriero Scafusiae. Collectors would pay just under half a million Swiss francs for his model.

On the banks of the Rhône in Vaud's Chablais is Castle Aigle, surrounded by vineyards. The 12th-century fortress, now a museum devoted to viniculture, was initially the residence of the governors of Bern, later serving as a prison until 1972.

Right:
Rivaz borders on one of the best vineyard locations in Switzerland's Lavaux, the Dézaley. This famous vineyard, once cultivated by Cistercian monks, produces top-quality Chasselas grapes.

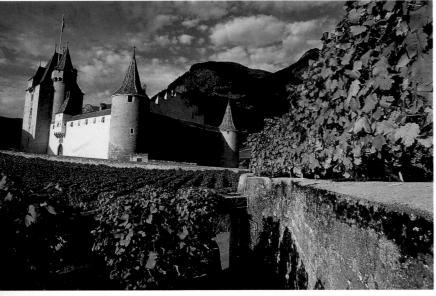

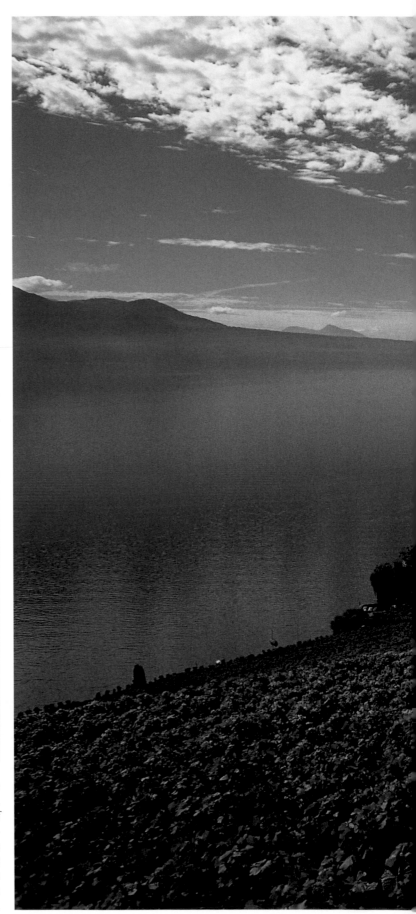

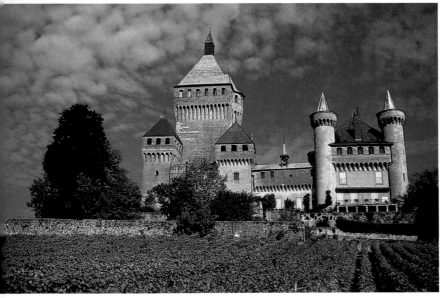

Above:
Heinrich von Colombier, vassal to the counts of Savoy, had Vufflens-le-Château above Morges constructed in brick in the northern Italian style between 1395 and 1430.

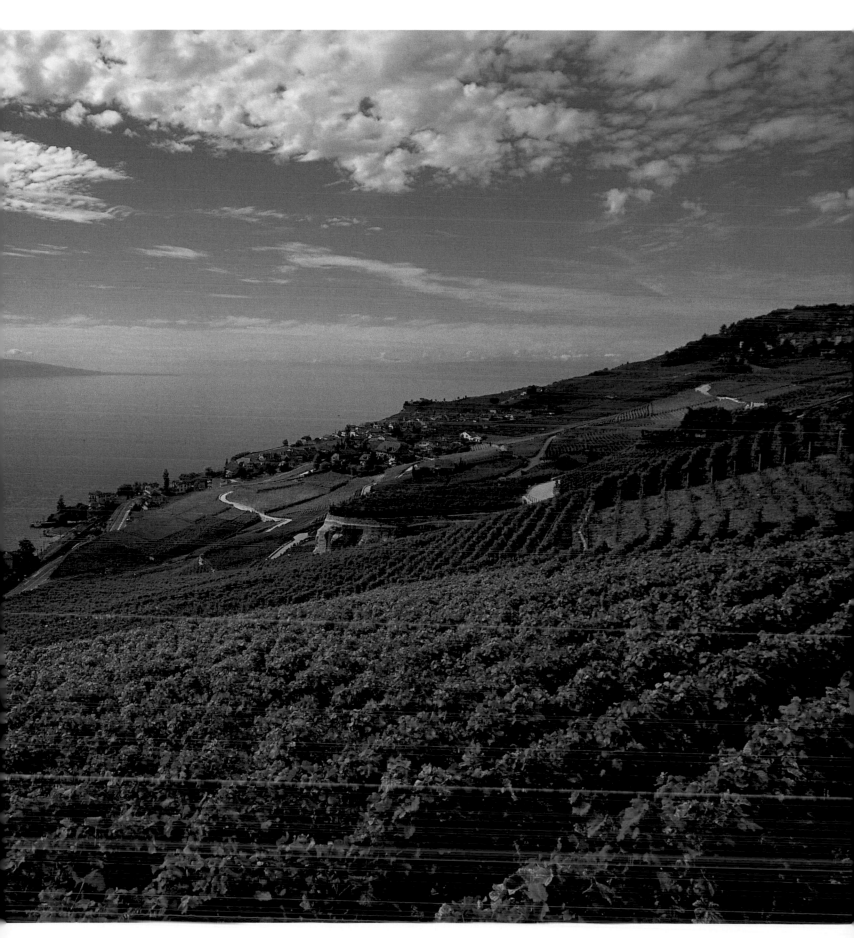

Below:
Lake Geneva is well
serviced by shuttles,
round trips and
cruises, water taxis
and pleasure yachts.

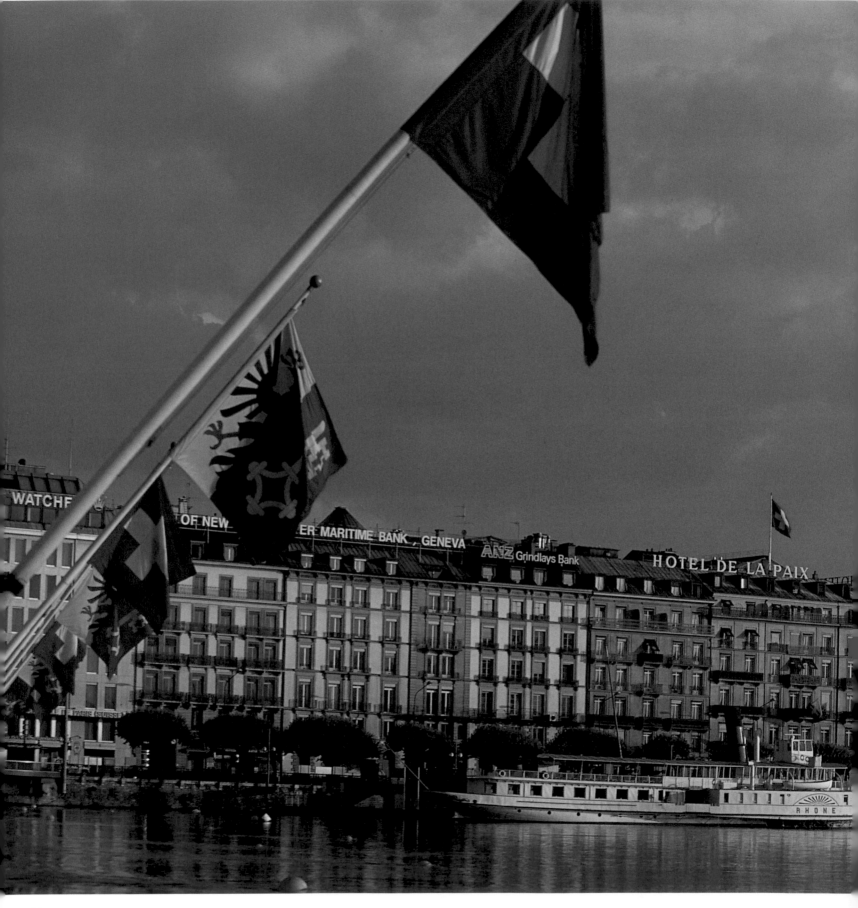

Below:
Paddle steamers chug
their passengers past the
Jet d'Eau and the most
favourable aspects of the
city of Geneva.

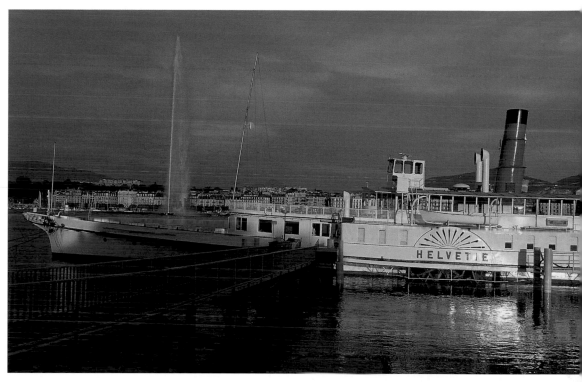

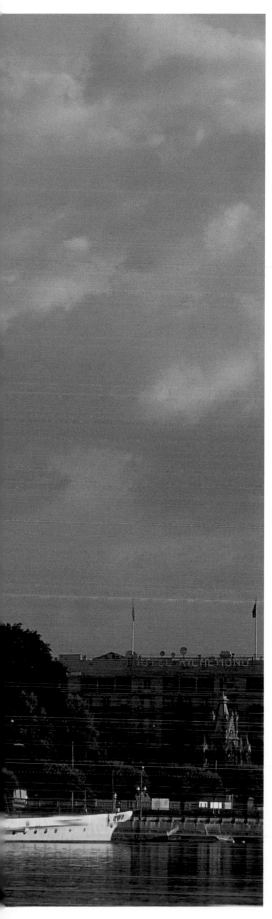

Above:
The dimensions of Lake
Geneva are truly colossal
(224 square miles/581
square kilometres,
45 miles/72 km long
and 9 miles/14 km at its
widest point), providing
plenty of scope for
all kinds of watery
activities.

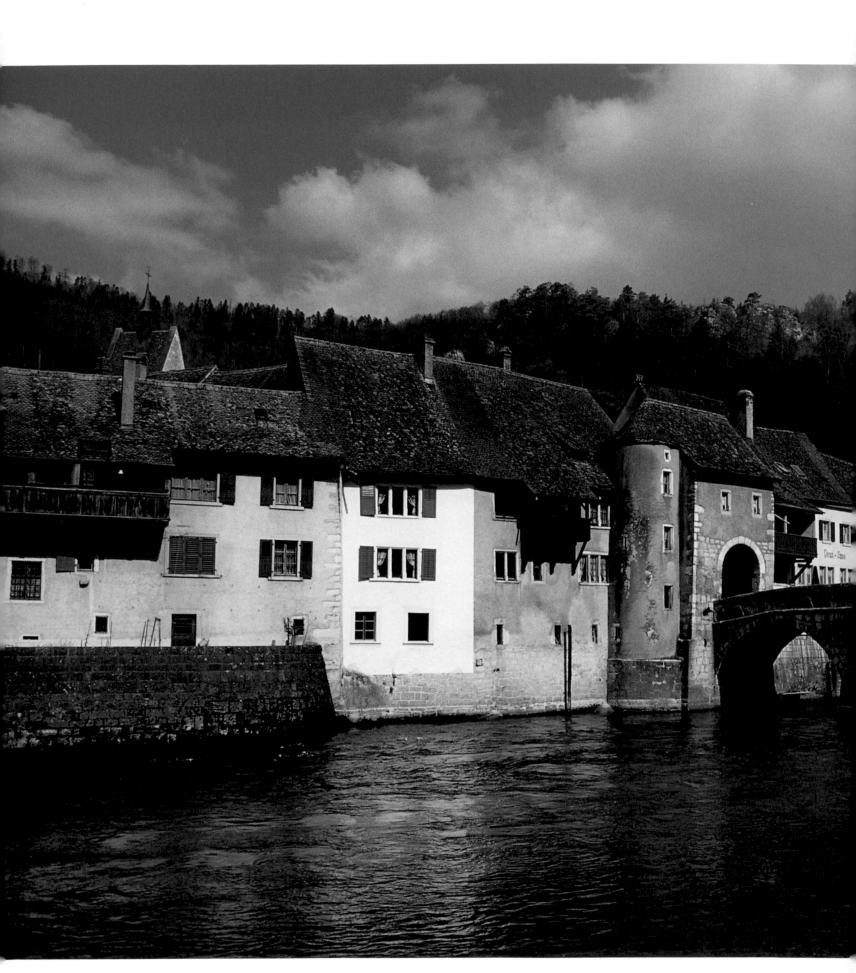

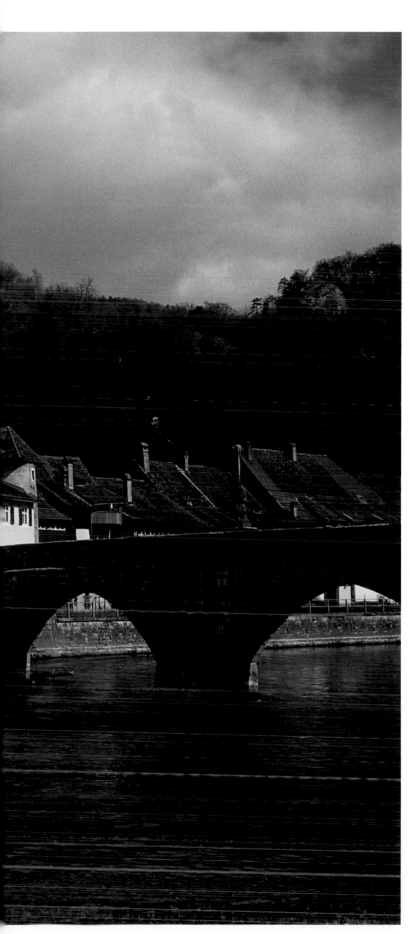

Left:
The Porte St Jean south gate to the historic town of St Ursanne in the Jura Mountains is reached via a bridge spanning the Doubs, erected in 1728.

Below:
Near the Col du Marchairuz (4,747 ft / 1,447 m).

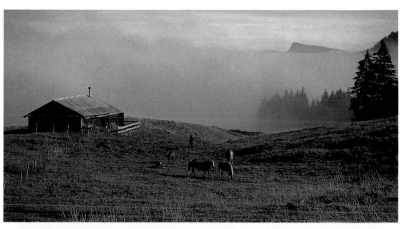

Above centre and above:
North of Lake Neuchâtel, between the clockmaker's town of La Chaux-de-Fonds and the valley of the Doubs River, which forms the border to France here, the countryside often seems dreamy and mystical. At Lake Brenets the Doubs Falls drop down a giddy 89 ft (27 m) before the river leaves Switzerland.

37

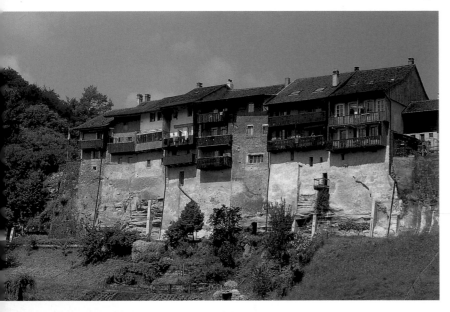

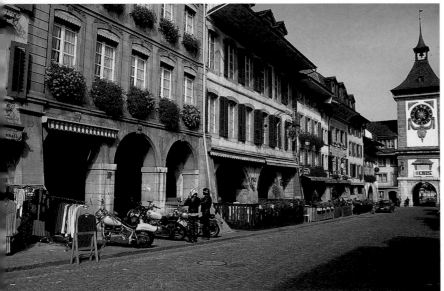

Above and top:
Moudon (top) in the Broye Valley in Vaud has Celtic and Roman origins and was long controlled by Bern. The town has many old houses boasting unusual architectural features. The buildings in Murten in the Fribourg canton also tell of a turbulent history. The main street with its magnificent city residences and shady arcades from the 16th century runs towards the Berntor from 1777/78, whose famous tower clock dates back to 1712.

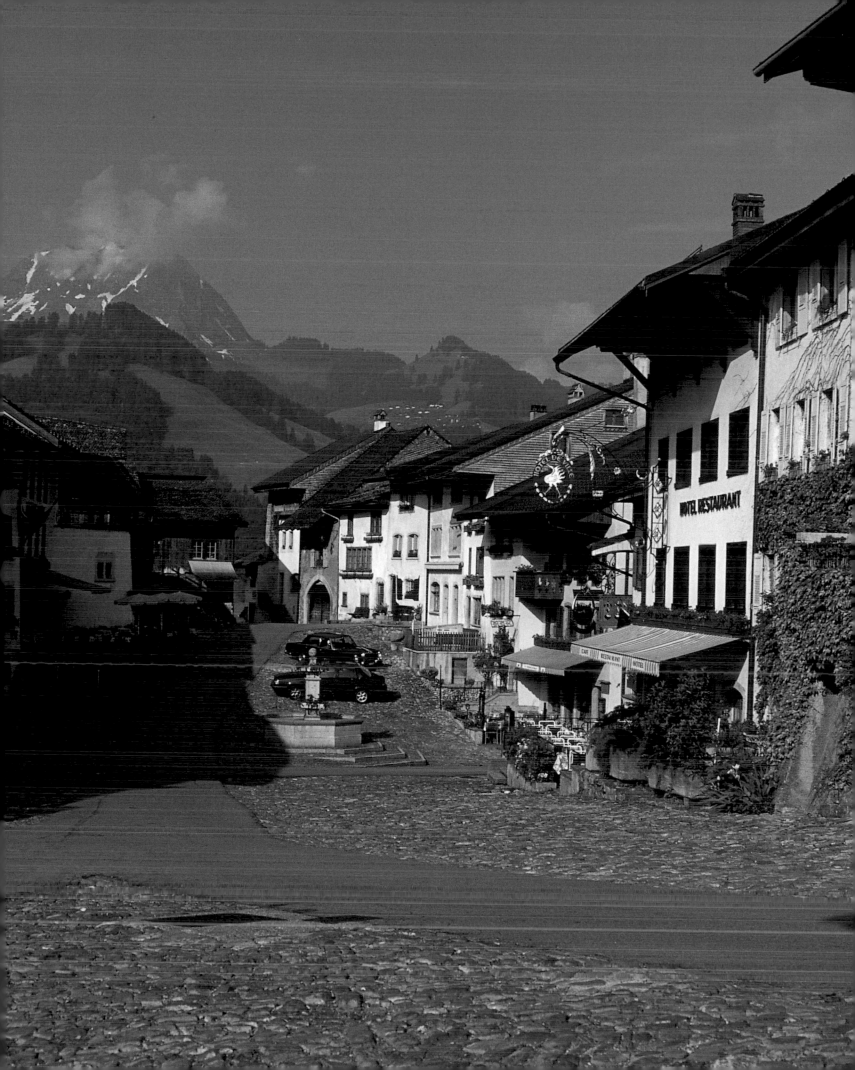

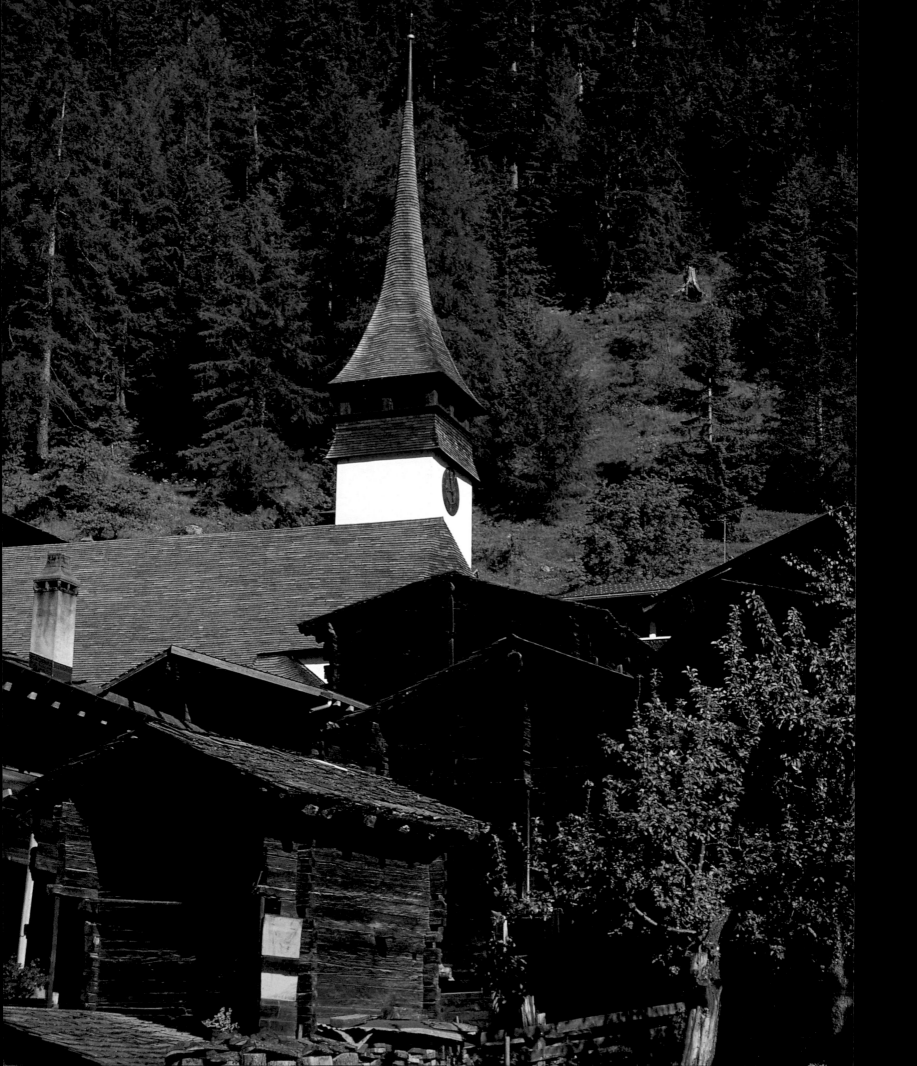

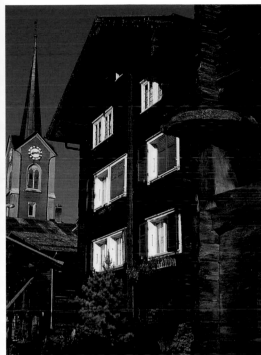

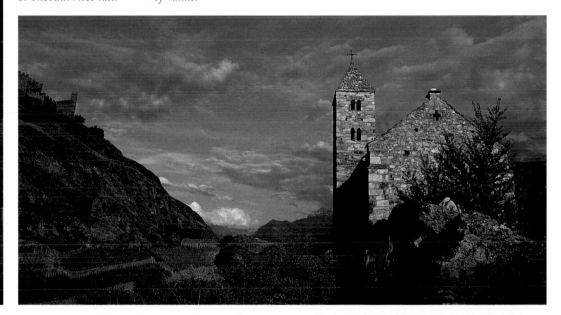

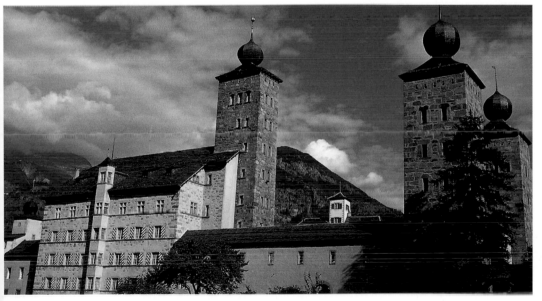

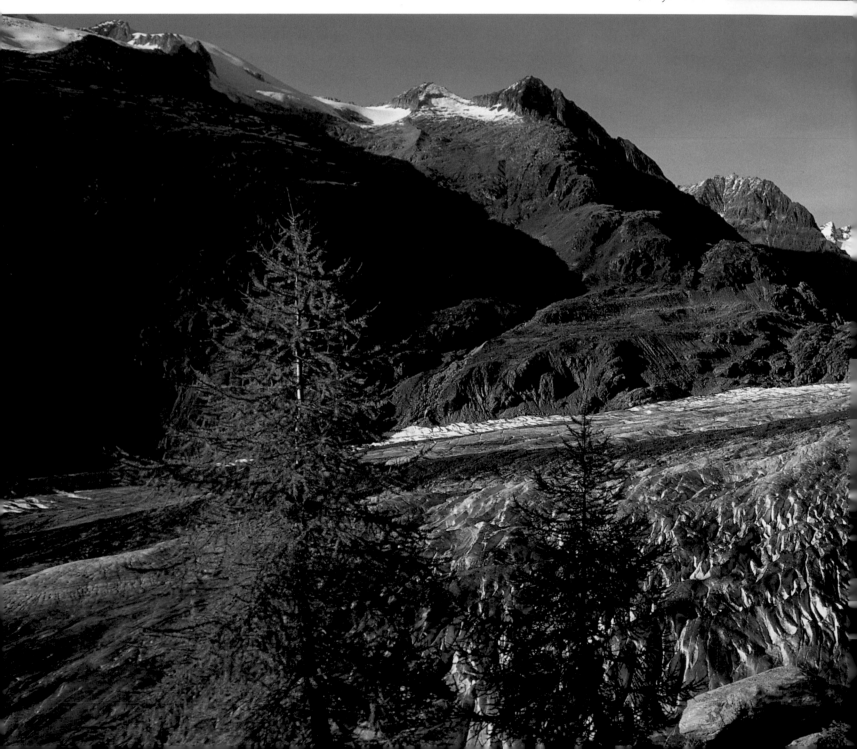

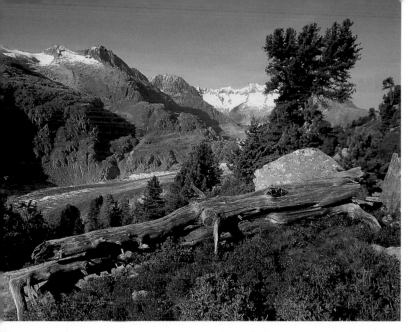

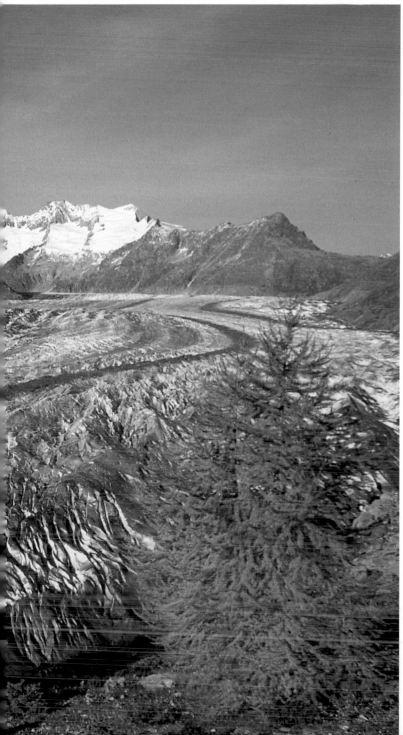

Below and below centre:
Expert mountain guides leading their entourage across a glacier, also called a firn or névé, have excellent knowledge of where the dangerous cracks and crevasses are, especially of those which aren't as obvious as the one here on the Aletsch.

Bottom:
Riederalp, the »gateway to the Aletsch Glacier and Aletsch Forest«, lies almost 6,400 ft (1,950 m) above sea level and is easily reached by cable car. Not far from Riederalp is the Blausee (7,231 ft / 2,204 m).

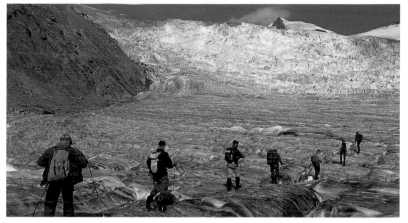

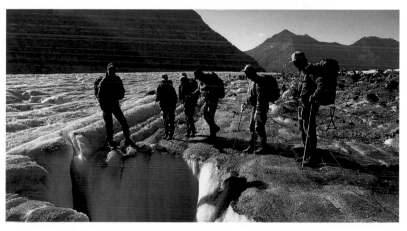

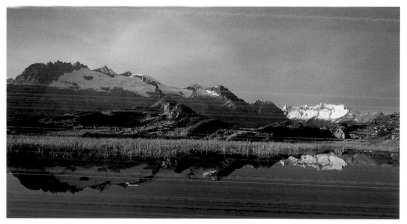

Bottom:
From the Dammastock near Andermatt, the Rhône Glacier creeps down almost as far as Gletsch. With a surface area of almost 120 square miles (300 square kilometres), this is one of the largest glacial areas in the Alps.

Below:
View of the frozen Gorner Glacier from Gornergrat, almost 10,270 ft (3,130 m) up.

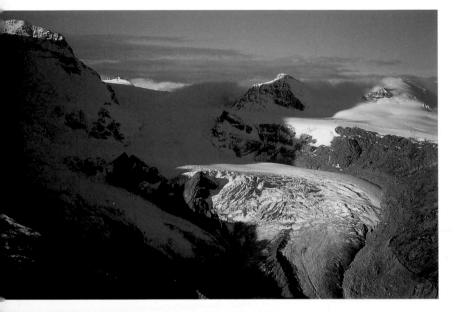

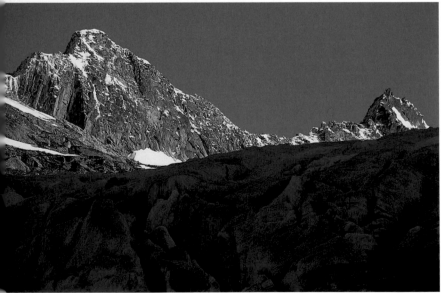

Right:
The Matterhorn is possibly one of the most famous peaks in Europe (14,692 ft/4,478 m). Each summer the mountain allegedly entices over 3,000 Alpinists to make the ascent from Zermatt via Hörnlihütte, a hazardous trek whose dangers should not be under-estimated.

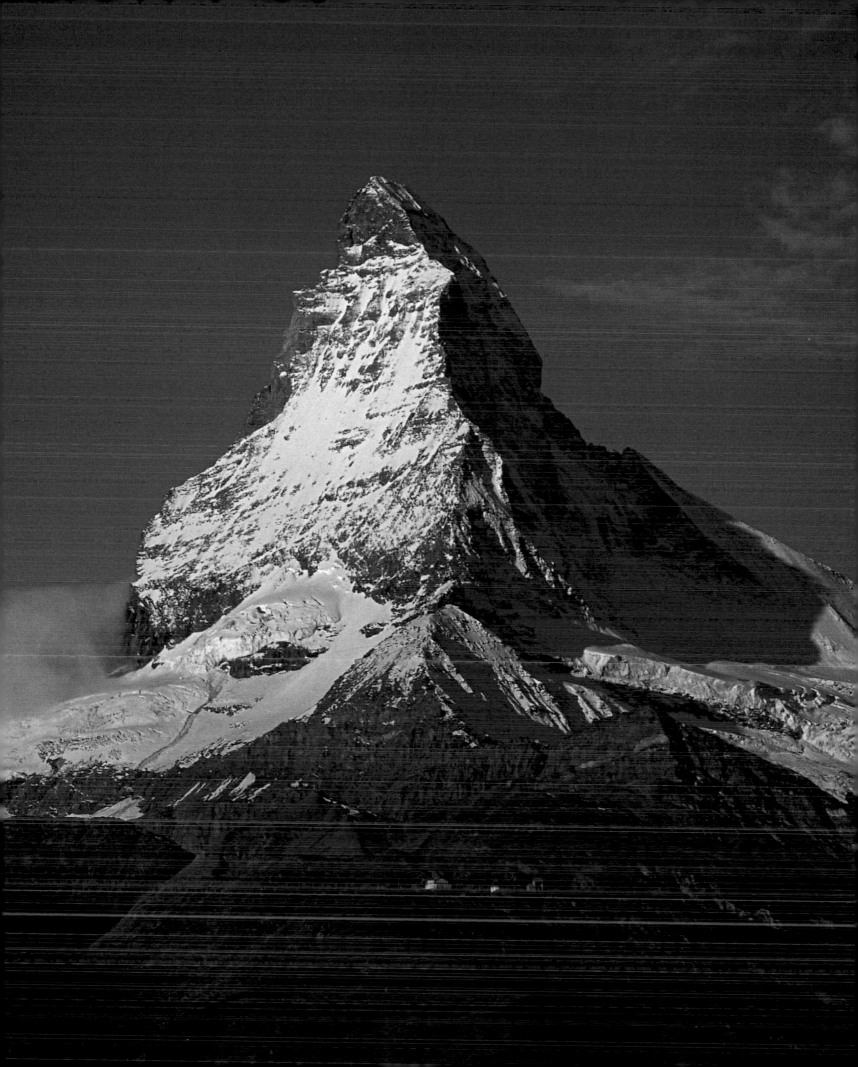

East of the Limmat River, the twin steeples of the great minster in Zürich illuminate the night sky.

The turrets were added in 1782; the church itself is from the 11th–13th centuries.

Around the heart of the Confederation at Lake Lucerne are grouped the cantons of Zug and central Lucerne; to the north is Aargau, which only became part of Switzerland in 1803, with the ancestral seat of the Habsburgs; and to the east are the cantons of Thurgau and St Gallen, whose history and culture seem to have more in common with that of the Lake Constance area than with Central Switzerland. The Appenzell region here is almost insular in character. It stretches out across a mere 160 square miles (415 square kilometres) of idyllic hilly countryside. Between St Gallen, Schwyz and Graubünden is the Glarnerland, once the hub of the textile industry, with a river which flows into Lake Zürich as the Linth and exits as the Limmat.

Basle, after Zürich and just beating Geneva as the second-largest city in Switzerland (176,000 inhabitants), is a Confederation outpost straddling both sides of the Rhine. At the point where Switzerland, France and Germany meet, the free city and centre of trade has always fulfilled a significant economic function. Basle Town and Basle District have been independent half-cantons since 1833. After Graubünden, Bern is the canton with the largest surface area, boasting a whole palette of scenery which ranges from Lake Biel in the north along the Aare River to the Hasli Valley in the south-east. Thun marks the boundary between the Bernese Mittelland and Oberland and the high mountainous region encircling the largest compact area of glaciers in the Alps. Here at the border with Valais are the Finster-aarhorn (14,023 ft/4,274 m), Eiger (13,025 ft/3,970 m), Mönch (13,448 ft/4,099 m) and Jungfrau (13,642 ft/4,158 m). The city of Bern joined the Confederation in 1353 and together with Zürich has always had a leading role in national affairs. As the political centre of Switzerland since 1848, Bern stands for continuity and bourgeois pride. Compared to Bern, the old town of Zürich »has none of the feudalism of Bern, none of the urbanity of Basle. It breathes the rationality of a small city of the gods which teaches its citizens to speak in prose«, to quote Adolf Muschg.

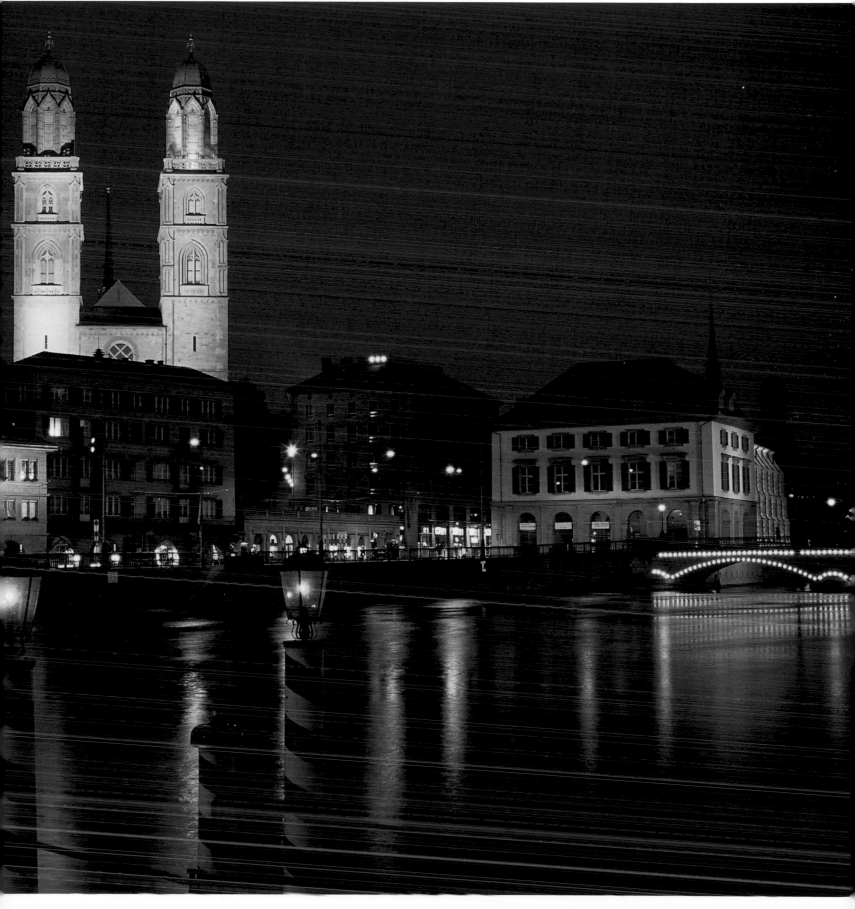

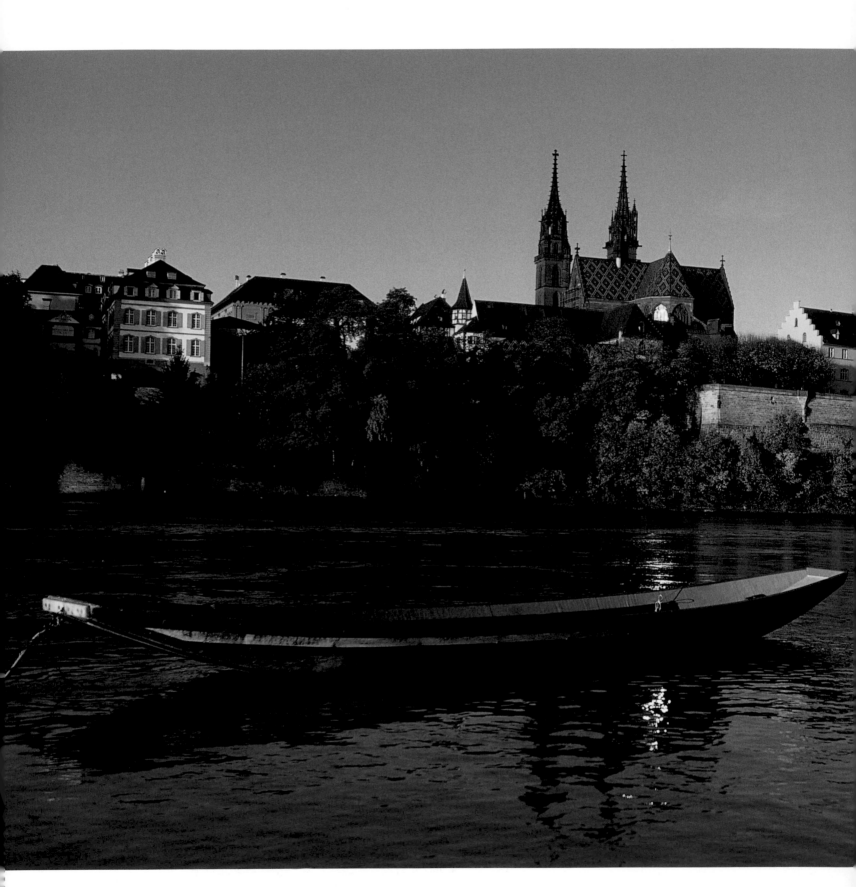

Above:
Basle Minster on its hill soars up above the city spread out on both sides of the Rhine. Following the destruction of the first church here during an earthquake in 1356, the present house of worship was rebuilt in Gothic from red Vosges sandstone.

Below and below centre:
The arterial Rhine and a favourable location on a bend in the river were to ensure Basle prosperity and success. Where Münsterplatz, a graceful ensemble in 18th-century, now stands (below centre) there was once a Celtic oppidum and later a Roman military post which formed the basis of the medieval town.

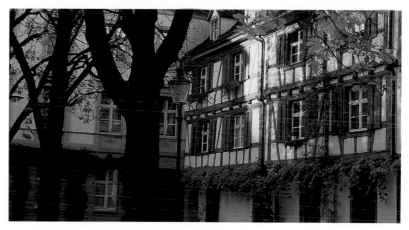

Above:
The façade of the late Gothic town hall in Basle has frescos by Hans Bock (1608–1611). The clock (1511/1512) is the creation of Master Wilhelms.

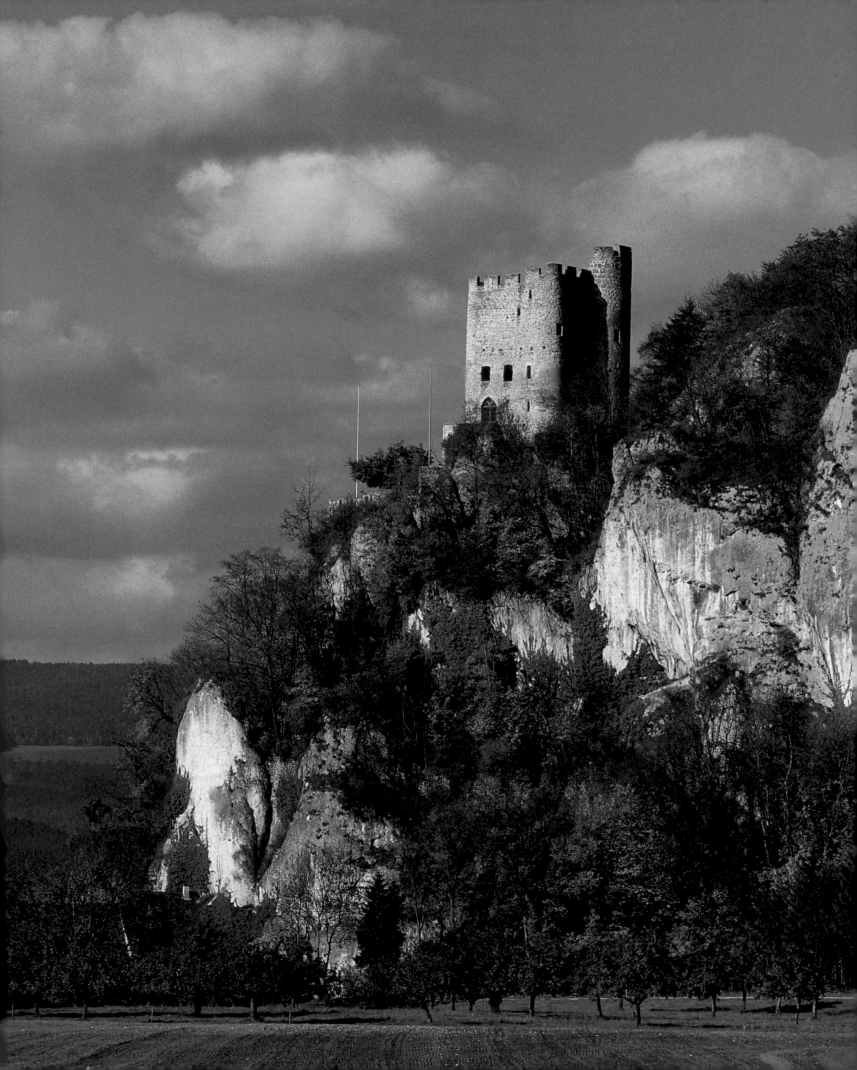

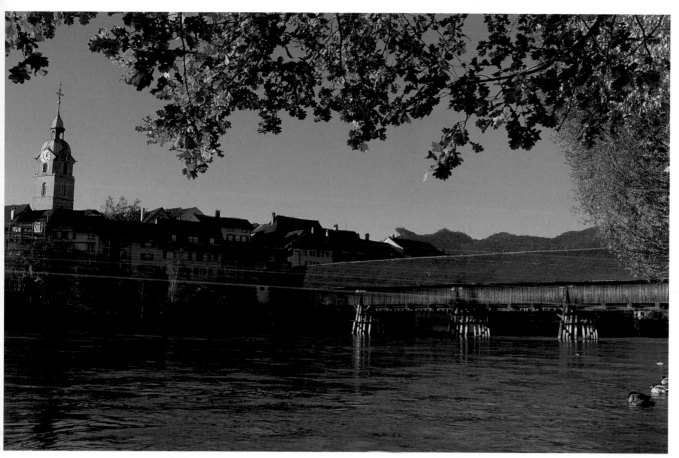

Far left:
All that remains of Thierstein Fortress near Büsserach, built in c. 1200, is the keep. The ruin in canton Solothurn guards the entrance of the Klus River into the Lüssel Valley.

Left:
The 200-year-old wooden bridge traversing the Aare River to the old town of Olten had a 13th-century predecessor. The late Gothic clock tower from 1521 in the background was once part of the parish church of St Martin, now dismantled.

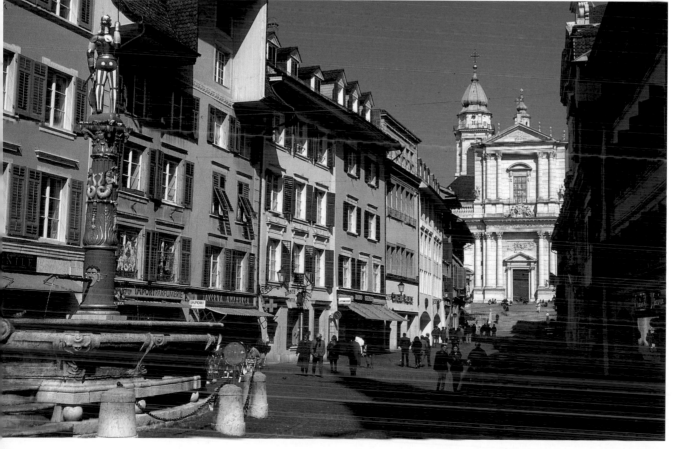

Left:
Solothurn's Hauptgasse culminates in the cathedral of St Ursen, erected from 1763–1773 in the style of the Italian baroque. The fountain in the foreground sports a statue of Fribourg master Hans Gieng from 1556.

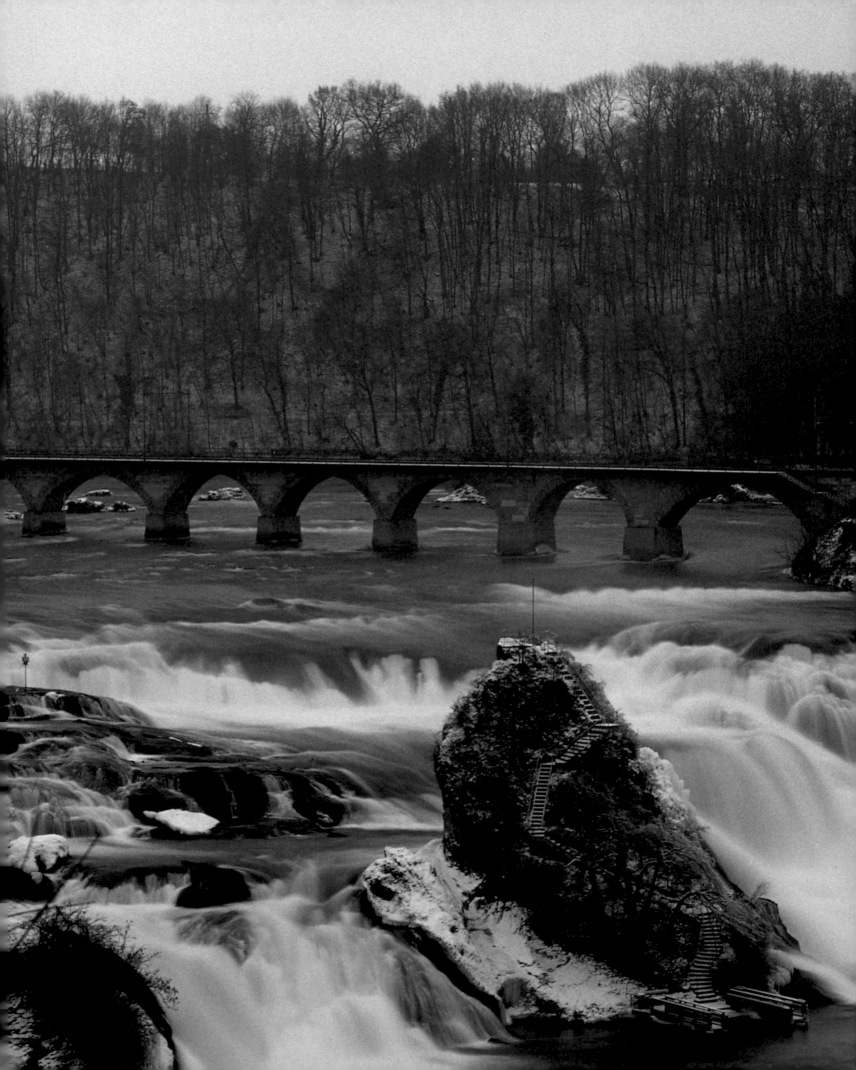

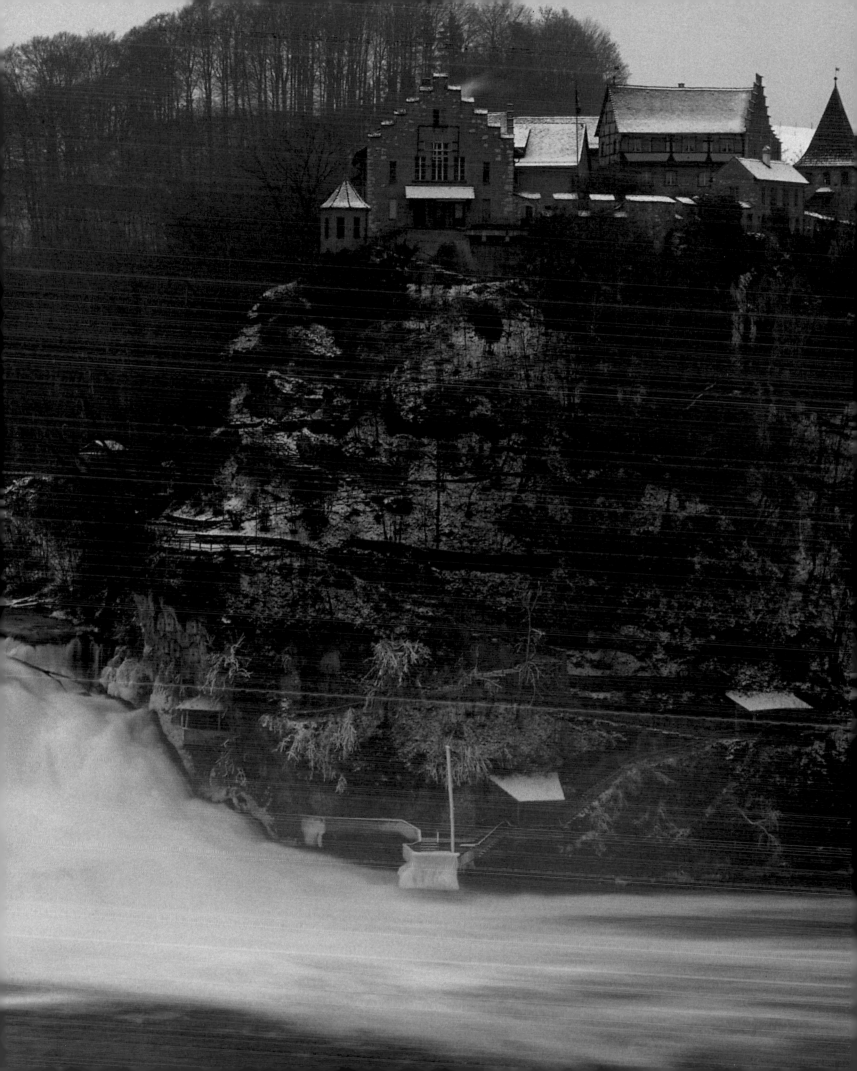

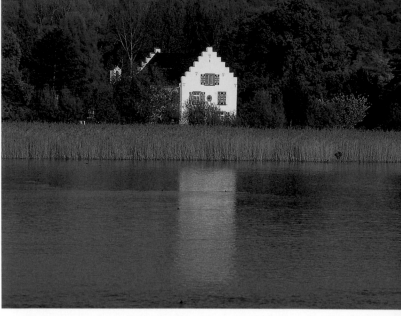

Right and above:
*Drastic efforts have
been made to clean up
Lake Constance (total
surface area 220 square
miles/571.5 square kilo-
metres, ca. 34% of which
belongs to Switzerland),
with the result that the
water is now almost
drinkable. The many fish
which lurk in its depths
provide professional
fishermen with a means
of making a living.*

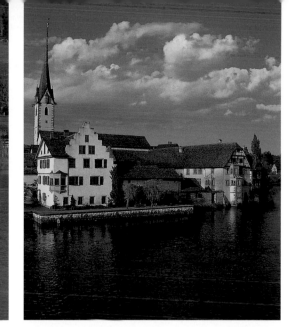

Page 52/53:
About 2 miles (4 km) southwest of Schaffhausen, the Rhine, almost 500 ft (150 m) wide at this point, hurtles down 75 ft (23 m) of Jura limestone cliffs into the depths. The Rheinfallbrücke, 630 ft (192 m) long, takes you across the rapids to the 16th century castle of Laufen.

Left and centre left:
Where the Rhine leaves Lake Constance, Stein am Rhein attracts hoards of visitors with its wonderfully preserved medieval centre and late Gothic tower of St Georgen monastery.

Below:
Lake Constance is split into the Obersee, Überlinger See and Untersee. On the southern shores of the lake, on a peninsula of the Untersee, is idyllic Steckborn, with its local landmark Schloss Turmhof from c. 1320.

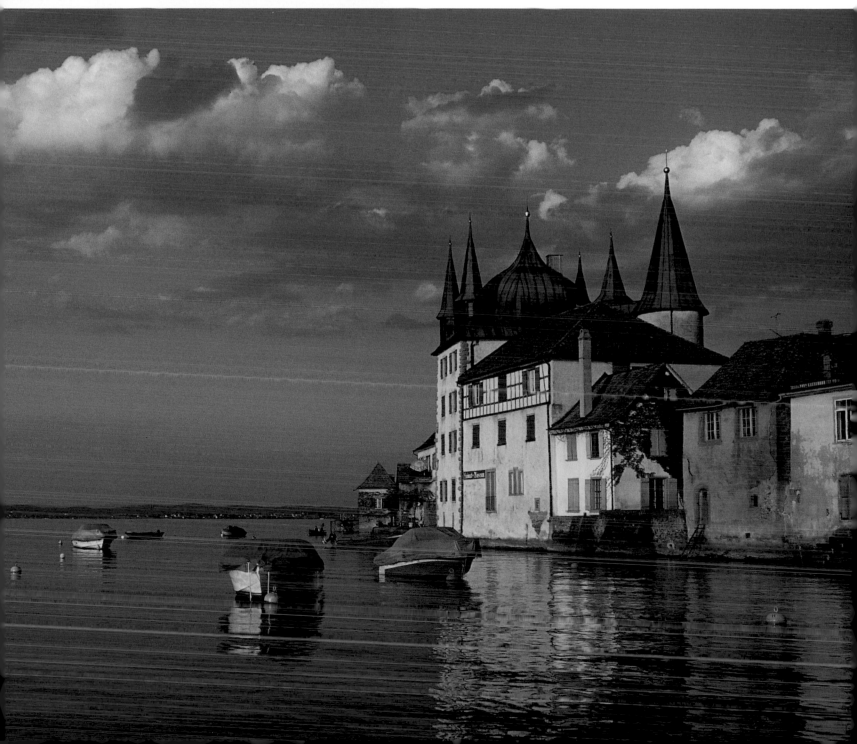

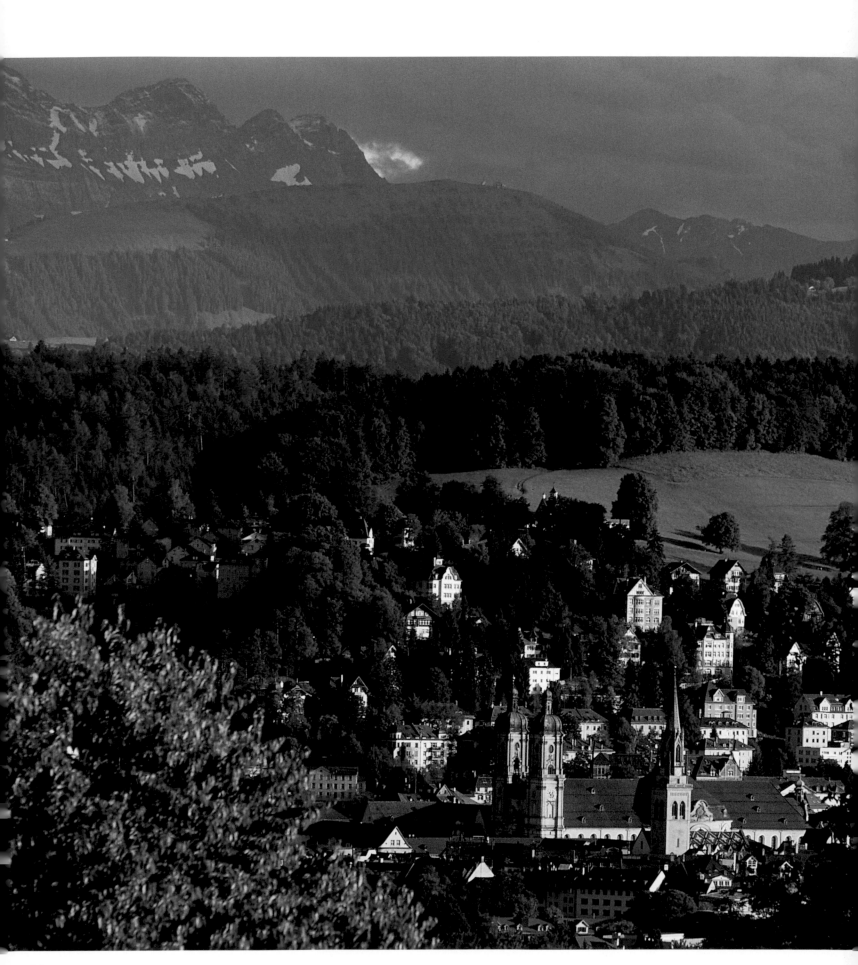

Left:
St Gallen in the foothills of the Alps southwest of Lake Constance goes back to a hermitage founded by the Irish monk Gallus in the 7th century. In the 9th century, the town was one of the more significant religious centres north of the Alps. The canton's capital is still the economic and cultural hub of northeast Switzerland.

Below:
The town of St Gallen, made a free city in 1212, sprang up around the Benedictine abbey. The monastery complex, which underwent excessive rebuilding and refurbishing in the 18th century, is now mostly in the style of the late baroque and Rococo.

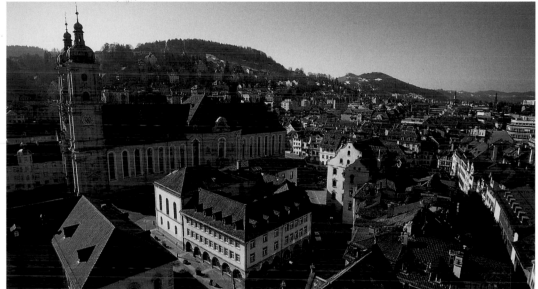

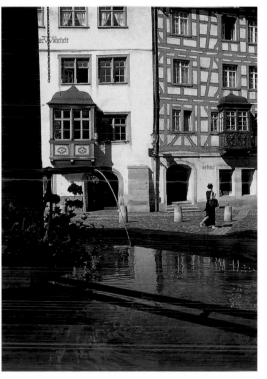

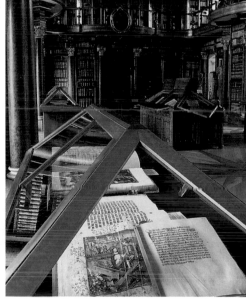

Above:
The old town of St Gallen boasts a multitude of architectural fashions – from medieval half timbered houses to the late Gothic constructions on Spisergasse to the Art Nouveau façades of Multergasse.

Above:
The copious archives of the monastery library hold 2,000 manuscripts, among them a version of the »Song of the Nibelungen« from the 13th century, and 1,650 early printed books.

The Appenzellerland still practises many of its traditional customs and ancient crafts. In Stein, where a huge cheese dairy demonstrates its methods of production to visitors, there are still coopers plying their trade.

Above and top:
The Alpfahrt in spring takes farmers and animals up the Schwägalp (4,209 ft/1,283 m) in the Toggenburg region of the Alpstein Massif.

Dairy farming in the Alps has a long tradition, as does the art of making a whole range of cheeses from milk curd and rennet. The Alpine word for a dairy, Sennerei, goes back to a Celtic expression for »to milk«; the word »cheese« itself has its roots in the Germanic and Latin. French fromage and Italian fromaggio are derivations of Latin forma, the clay pot used for draining the liquid from quark or cream cheese. The Romans were expert cheesemakers, also importing »holey« varieties from the northern reaches of the Alps. Incidentally, the holes the size of cherry stones in Emmentaler are caused by gas pockets of carbonic acid forming while it matures over 3 to 12 months. The more symmetrical the holes, the better

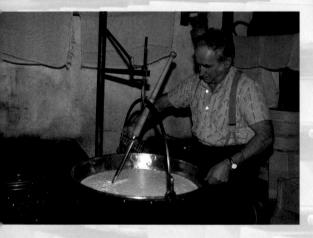

the cheese. Swiss Emmentaler is naturally very different from its many imitations throughout the globe; it owes its characteristic taste to the flavoursome Alpine pastures the cows graze on. The regional differences in temperature cheese is exposed to during manufacture and maturity, the type of milk used and the degree to which it is processed are all instrumental in determining the distinctive quality of a cheese.

There are Gruyère, with only few pea-sized holes, Sbrinz, which matures for up to 3 years, and Schabzieger, Appenzeller, Vacherin, Urseren and Tête de Moine, originally from Bellelay Abbey in the canton of Bern, to name but a few. Switzerland's contribution to the world's selection of cheeses is considerable. No less famous are the culinary uses for it, particularly fondue and raclette. The first is a mixture of Emmentaler, Gruyère, tangy white wine and a few

other ingredients; the genuine preparation method for the second (which is also known as Bratchäs or »frying cheese«), involves melting soft Goms cheese from Valais on a fork over an open fire, scraping the top layer into a hot plate, as Grandfather did at the first meal for his granddaughter in Johanna Spyri's »Heidi«.

While dairy farmers in Europe patiently stirred their vats of cheese over many centuries, happiest when manufacturing hard varieties which kept, a new delicious use for milk was brought back from the New World. Cocoa, the chocolate drink discovered by the Spanish in Mexico in the 16th century, gradually infiltrated the salons of Europe. The first advocates of the popular refreshment, the Aztecs, mixed dried, grated cocoa beans with water and chilli (Aztec chococ means bitter and aromatic, alt is water). The Spanish replaced the exotic chilli with milk and sugar, producing a beverage which soon became a status symbol among members of the aristocracy. The fashionable noggin spread from the Spanish court to the ranks of the French and Francophile elite, who merrily indulged their new-found passion for chocolate until the end of the ancien régime. The bean then found itself rather less of a public figure, becoming instead a focal point in the worlds of women and children.

»If you refer to coffee as a Protestant, northern drink, then you must call chocolate its Catholic, southern counterpart.«
(W. Schivelbusch in: »Schokolade«, Leipzig 1998)

Other than coffee, which began its march of triumph with the rise of the middle classes, chocolate contains hardly any stimulants. It is, however – much to the chagrin of those with a sweet tooth – all the more

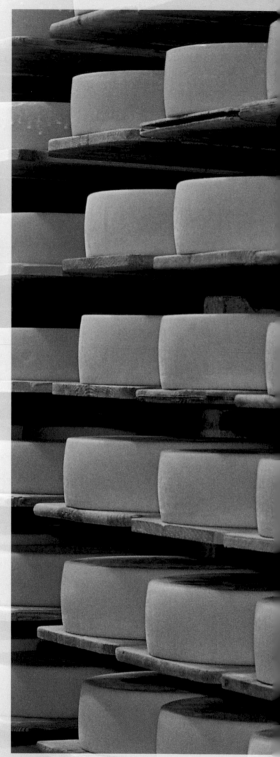

Far left:
It's always worth comparing the taste of cheese produced industrially with that of the traditionally manufactured Alpine varieties made from fresh milk.

Right and obove left:
The open cheese dairy in Stein in the Appenzellerland processes ca. 1,580 pt (900 l) of milk a day. In the cheese vat (right) the milk is made to separate and curdle and then sliced with the cheese

CHEESE AND CHOCOLATE

Jean Etienne Liotard of Switzerland (1702–1789) painted the »Chocolate Girl«.

nutritious for it. A bar of chocolate contains ca. 40% fat, 50% sugar and 10% flavourings, such as vanilla or vanillin. The type of cocoa beans used and their proportions govern the quality of the bar.

They paved the way for Swiss milk chocolate: François-Louis Cailler, Daniel Peter, Henri Nestlé, Rodolphe Lindt (from left to right).

With the invention of the cocoa press and a modern method of manufacturing chocolate by Dutchman Van Houten in 1828, chocolate drinks based on cocoa powder reached ever remoter parts of Northern and Central Europe. The first genuine chocolate bars were produced in 1847 by the English company Fry & Sons in Bristol to be sold by chemists as medicine. One of the ingredients was mercury. Swiss chocolate history features names such as Cailler, Suchard, Kohler, Lindt, Sprüngli and Tobler. Henri Nestlé, for example, had performed successful experiments with milk powder several years before Daniel Peter launched the first milk chocolate in 1875. Shortly after the opening of a milk condensation plant by the Page brothers in Zug, in 1867 Nestlé founded his own milk powder factory in Vevey on Lake Geneva. An important innovation for the chocolate industry was made in 1879 by Rodolphe Lindt, who hit upon a way of making the candy smooth and creamy. His conching process involves mechanically churning the sticky melange in what were originally shell-shaped vats (or conches) until it takes on a homogenous, velvety consistency.

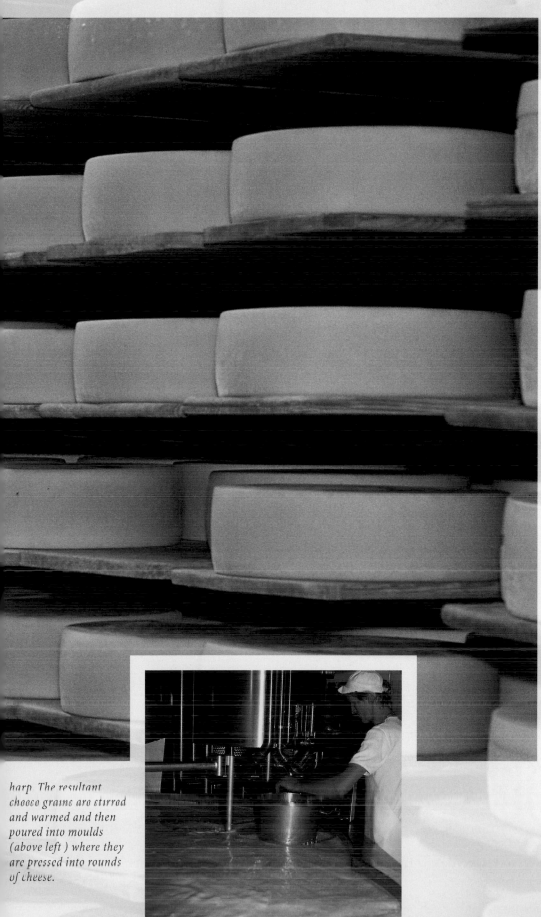

harp The resultant cheese grains are stirred and warmed and then poured into moulds (above left) where they are pressed into rounds of cheese.

Below:
The tiny Schottensee
southwest of Bad Ragaz
in the Pizol area
(9,344 ft/2,848 m)

is the ideal place to
pause when you're out
hiking up in the
Glarner Alps.

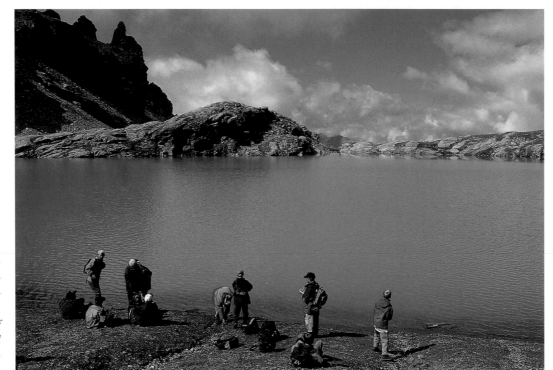

Below:
The highest point of the
Alpstein Massif is the
Säntis (8,215 ft/2,504 m),
where the boundaries of
St Gallen canton and
Appenzell's two half-
cantons converge.

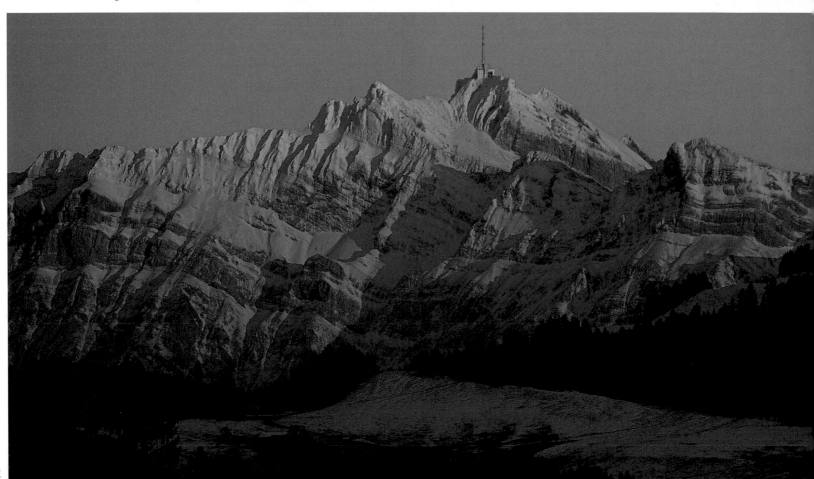

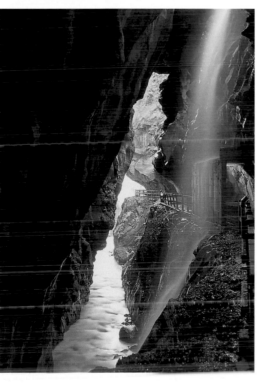

Left:
Two intrepid mountaineers climbing up ice in Weißtannental, which runs southwest from Sargans to the Foopass.

Above:
There's a track winding along the Tamina Gorge (1,640 ft/500 m long) near Bad Ragaz.

63

Below:
Near Flums the ruins of Gräpplang Castle tower up above the valley of the Seez. The castle was the seat of the Tschudi dynasty from Gräpplang from 1528 to 1767.

Below centre:
Sargans is dwarfed by the chapel of St Sebastian on Splee from 1502 and the castle, whose late medieval keep is shown in the photo.

Right:
It's a dizzy climb up almost 500 ft (150 m) from Berschis near Walenstadt to the pilgrimage chapel of St Georgen, built on this wooded, rocky ledge in the 12th and 15th centuries.

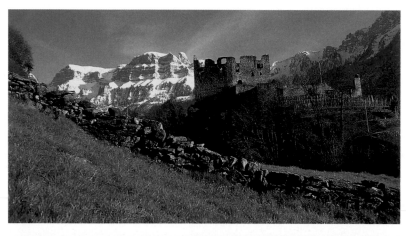

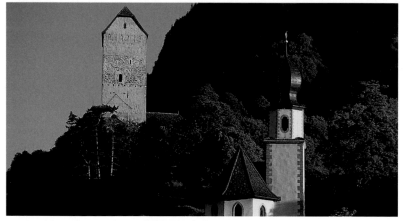

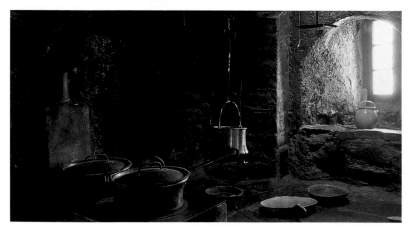

Above:
The tower of Sargans Castle, once the ancestral seat of the counts of Werdenberg-Sargans, now houses a museum. The exhibits document the early and cultural history of the area (the photo shows a medieval kitchen). There's also a museum dedicated to the Gonzen mine.

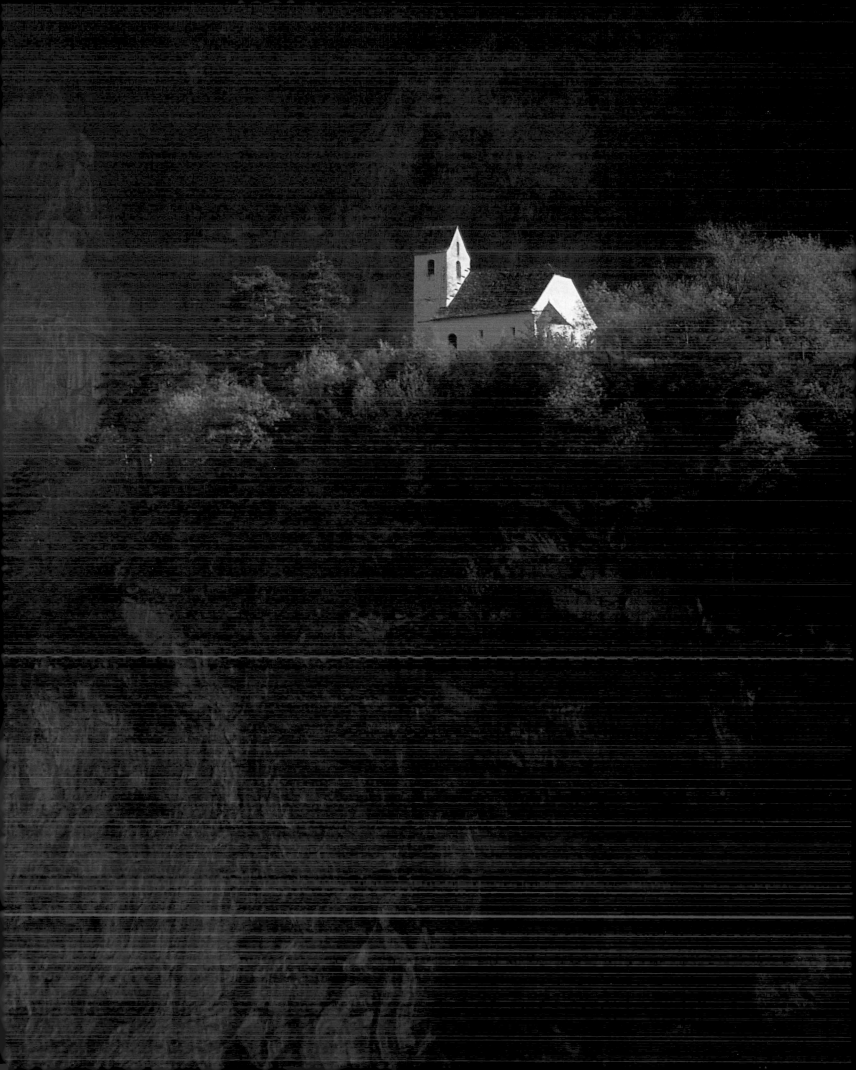

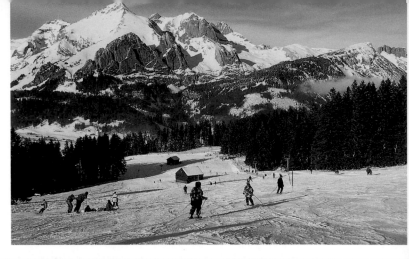

Right:
The Wildhaus area has plenty of lifts and is extremely popular with winter sports fanatics.

Below:
A calf being led through the snow at Weißtannen in the Seez Valley.

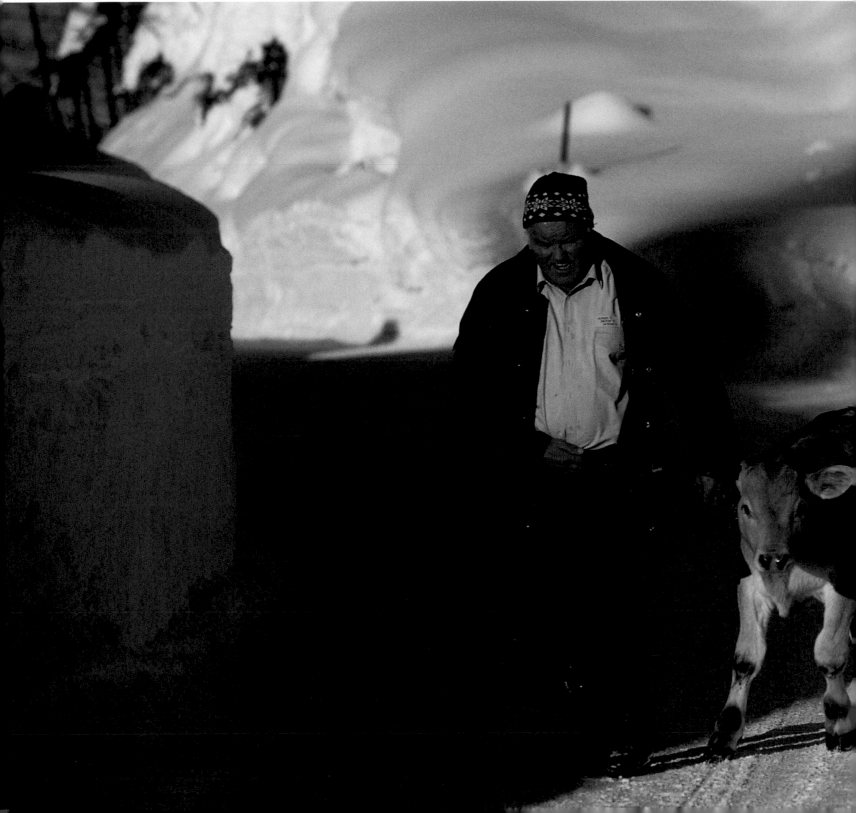

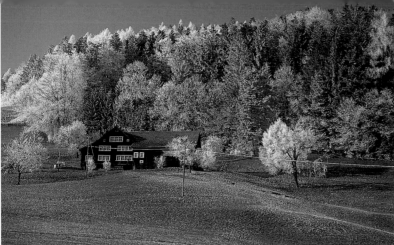

Left:
*Many farmsteads were
erected a long way from
the next village, such as
Einödhof here near
Schachen.*

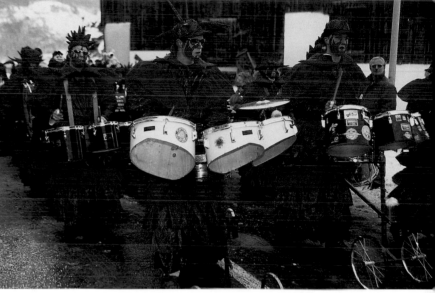

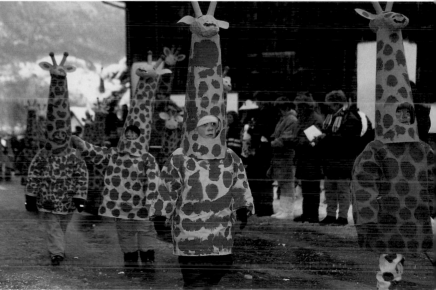

Above and up above :
*Carnival (here at Wangs)
heralds the arrival of
colourful processions
where people dress up in
masks and costumes, not
all of them completely
authentic.*

Right:
Augustinergasse in Zürich's old town with its magnificent houses, restored down to the last original detail.

Below:
Zürich provides an elegant showground for trick cyclists and the like.

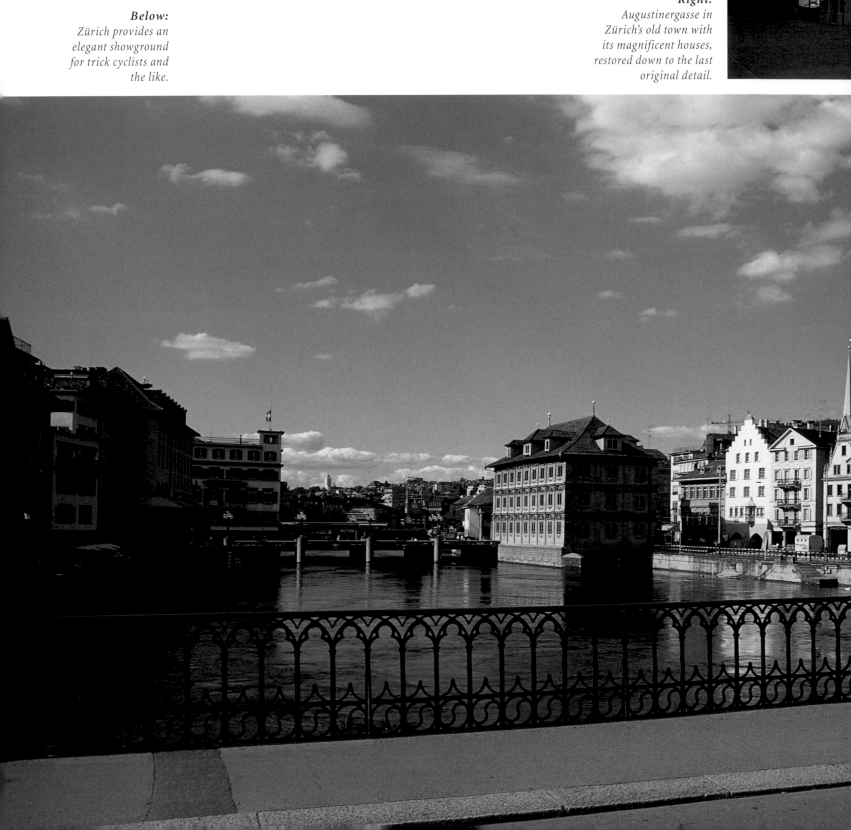

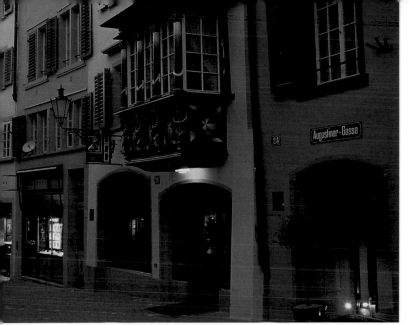

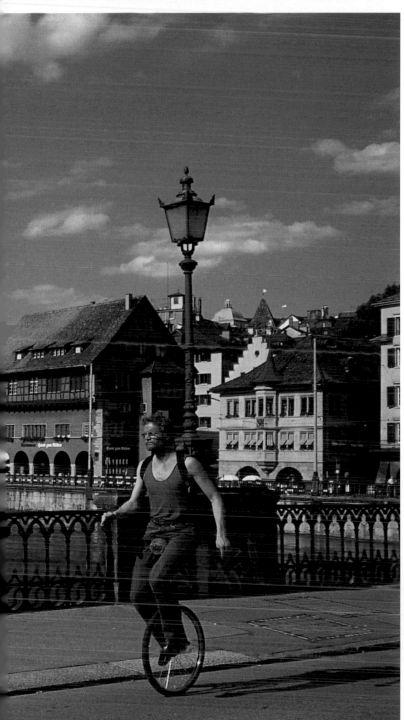

Below:
*Utoquai on the eastern
shores of Lake Zürich is
a great place to relax.*

Below centre:
*The place where
Bahnhofstraße widens
into Paradeplatz was
and still is a hive of
activity in Zürich. In the
18th century a pig market
was held here, the square
later being used as a
parade ground.*

Bottom:
*The tower of St Peter's
was given its clock faces,
the biggest in Europe,
in 1538. They measure
29 ft (8.7 m) across.*

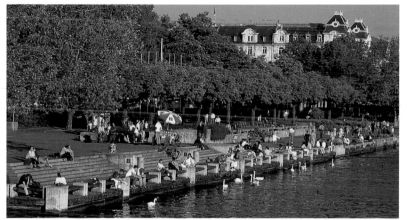

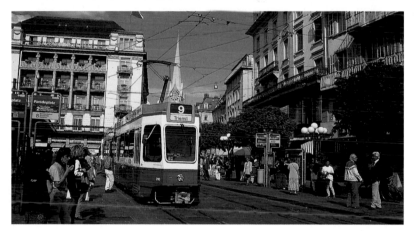

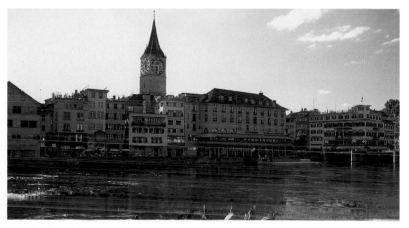

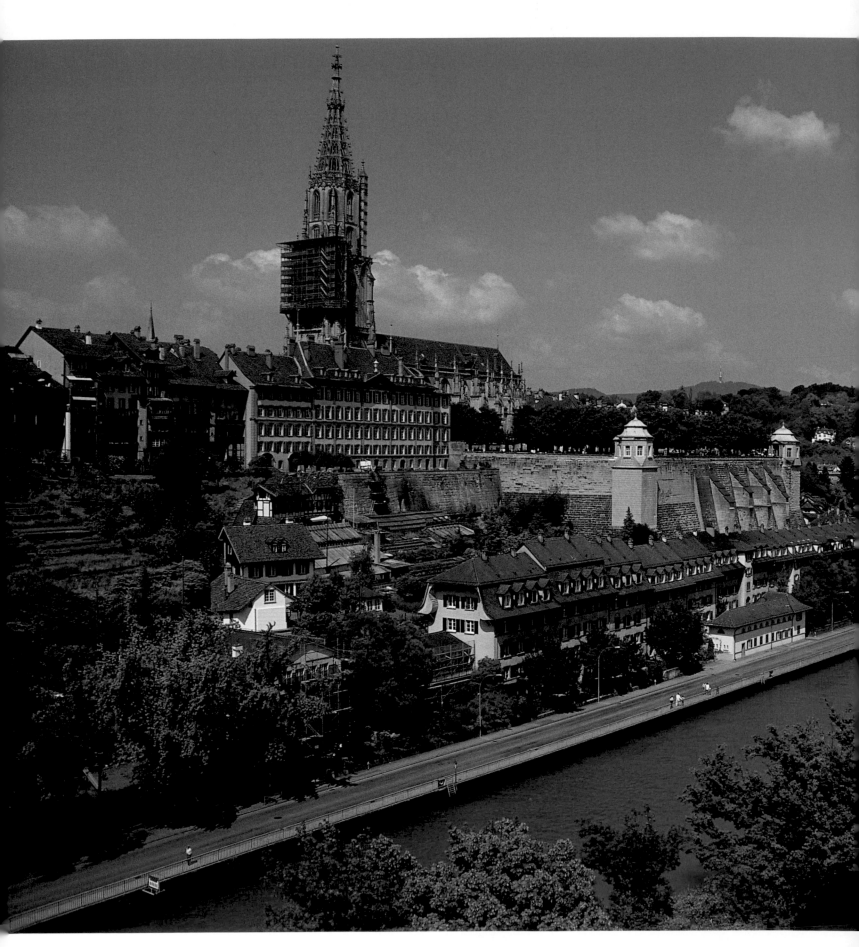

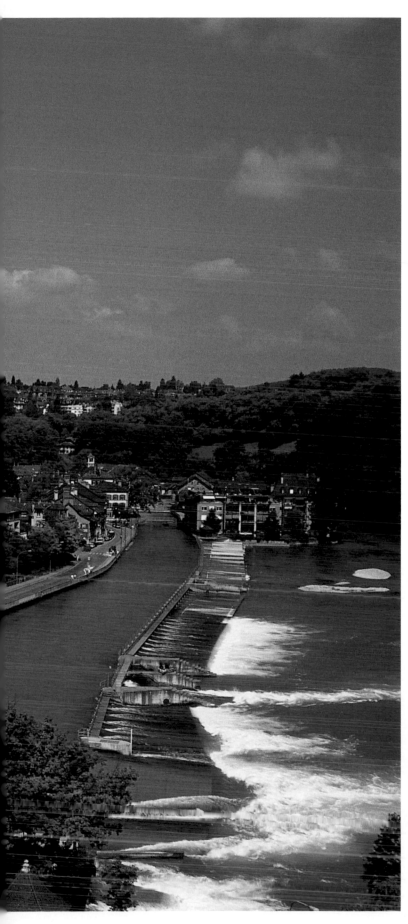

Left:
Bern's old town fans out across a sandstone ridge, protected on three sides by the Aare River and surmounted by the late Gothic minster of St Vinzenz.

Below:
Kramgasse with the Albert Einstein Haus ends at the Zytglogge-turm, until c. 1250 the west gate of the city of Bern, now much altered. The astronomical clock was fashioned by Kaspar Brunner between 1527 and 1530.

Below centre:
The minster casts a distinctive shadow on the houses and streets of the Altstadt.

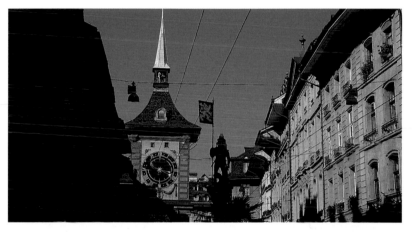

Above:
In 1461 the Untertorbrücke was erected in stone to replace an earlier wooden construction, providing Bern with its only permanent river crossing until 1844. Since then a number of high bridges has been built, among them the Nydeggbrücke.

Below:
South of Interlaken a hiker's paradise of lush meadows and steep limestone rocks awaits: the Lauterbrunnen Valley, stretching as far as the Jungfrau Massif.

Right:
The River Aare trickles out of the Oberaar Glacier in the Bernese Alps, arches west and north in wide sweeps before eventually flowing into the Rhine near Koblenz. In the Hasli Valley between Meiringen and Innertkirchen, the young river forges its way through a canyon up to 4,590 ft (1,400 m) long and 650 ft (200 m) wide.

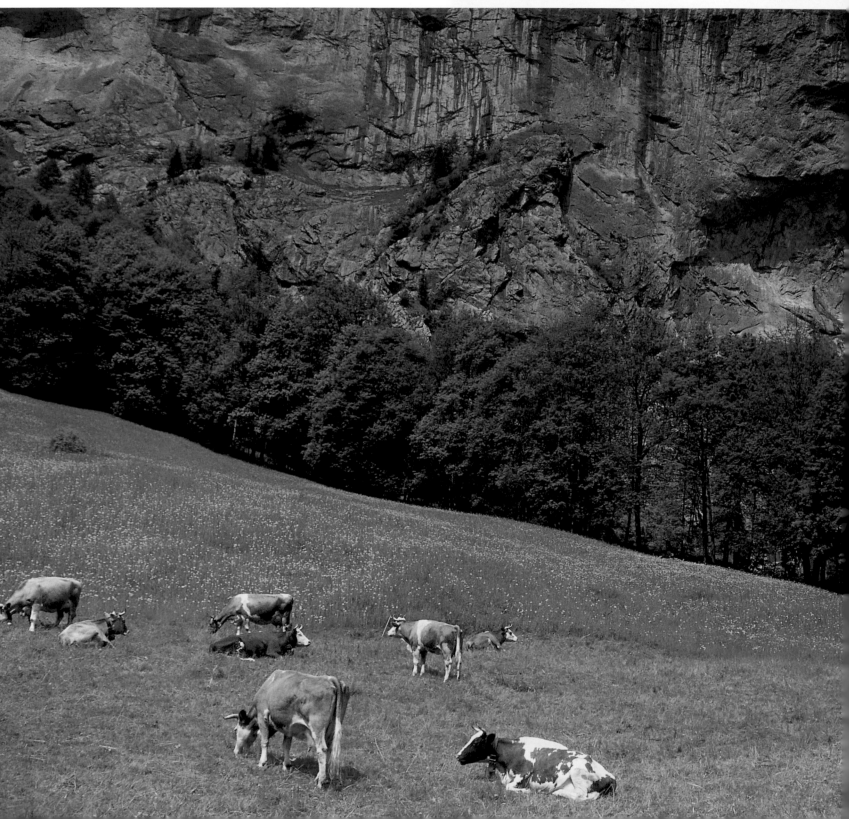

Left:
On the southern shores of Lake Brienz the Gießbach dramatically crashes down 14 tiers of rock over 980 ft (300 m) high before entering the lake.

Page 74/75:
The silhouette of the mighty Schreckhorn, Mönch and Eiger from the Gauli, bathed in the warm light of the setting sun.

Above:
Inside the glacier, shrouded in an ethereal blue light, it's like being in another world.

Left:
You have to cross a wooden bridge to get into the man made ice cave in the enormous Oberer Grindelwald Glacier, almost 4 square miles (10 square kilometres) in size.

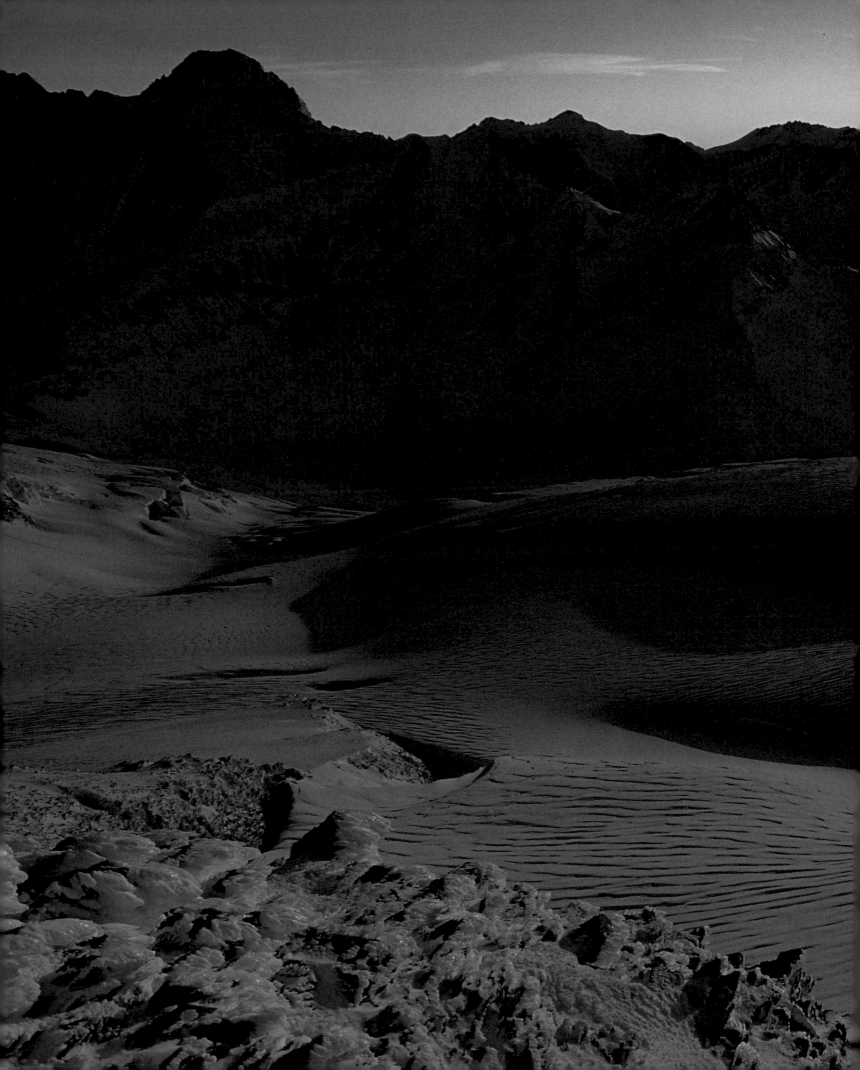

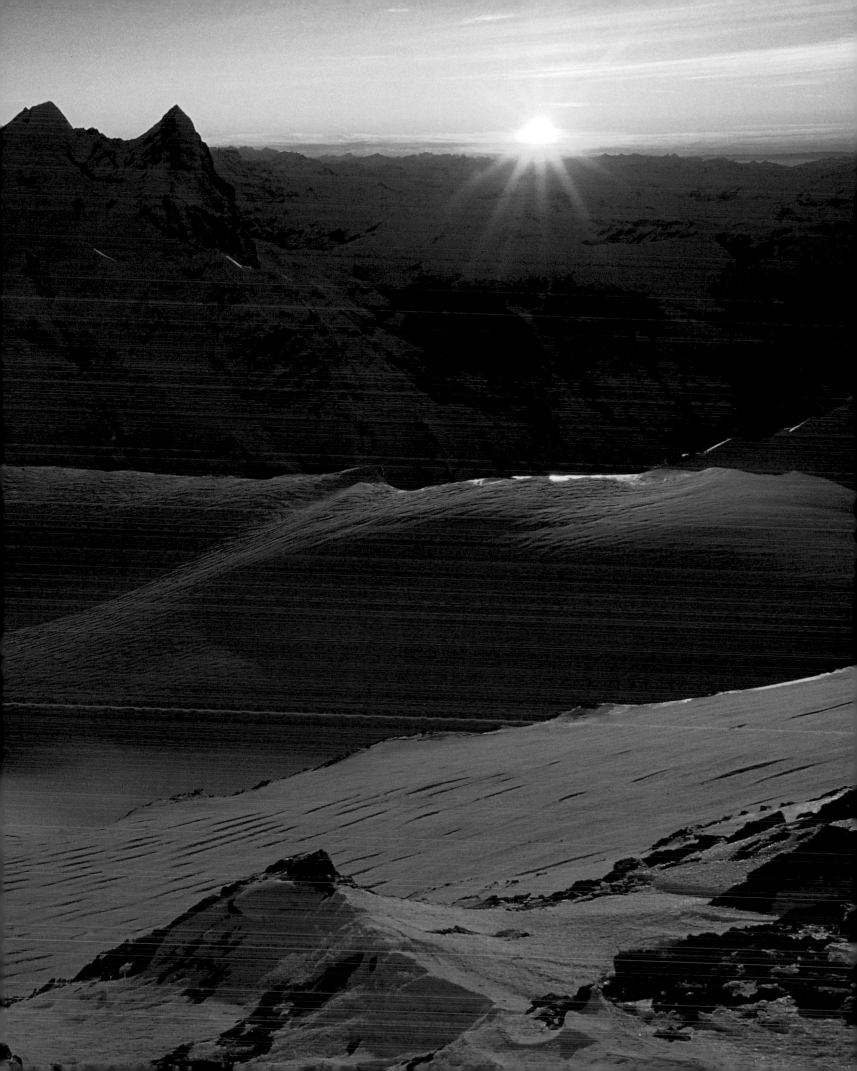

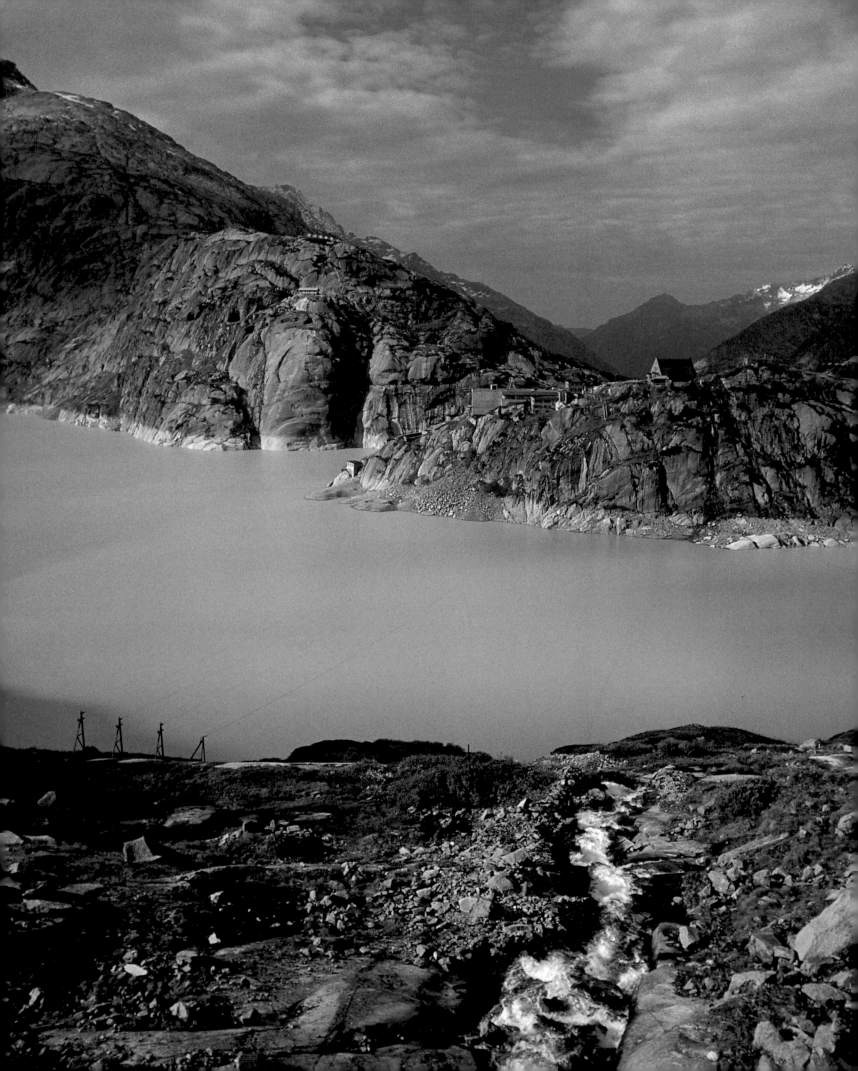

Left:
You pass two other lakes before reaching the Grimselsee at 6,263 ft (1,909 m), which sprawls fjord-like across the 3 miles (5.5 km) from the Unteraar Glacier to the dam.

Below:
The road continues to wind up to the Grimsel Pass at 7,103 ft (2,165 m) which forms the border between the cantons of Bern and Valais.

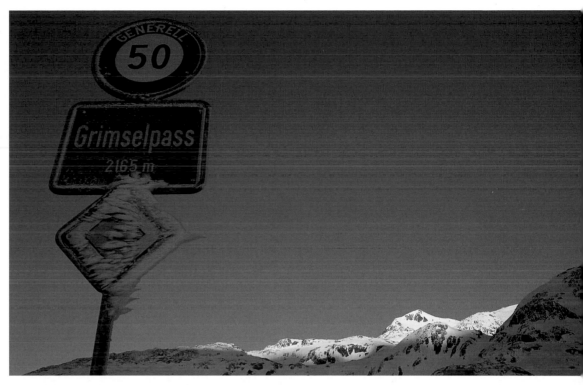

Above:
Until 1894 the Grimsel Pass was nothing more than a mule track. The area has now long been serviced by well-surfaced roads, enabling motorists, bikers and even cyclists to enjoy the fantastic panoramic views.

Below:
Bernese Mittelland
farmsteads in Emmental
near Schangnau (below),

in Eggiwil (bottom)
and in the Trub Valley
(below centre).

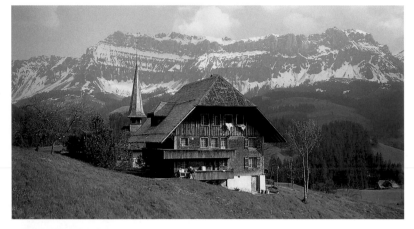

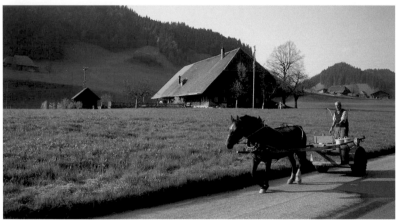

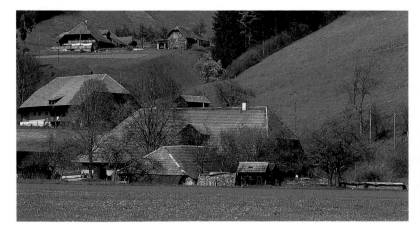

Left:
*South of Bern, such as
here in the Gürbe Valley
near Belp, many of
the farmhouses have
glorious summer floral
displays.*

Below:
*Switzerland could deck
over half its requirement
in food with its own
produce, yet agriculture
makes up only 3% of the
gross national product.
Swiss agronomy concen-
trates on cattle farming,
with milk its most
important product.*

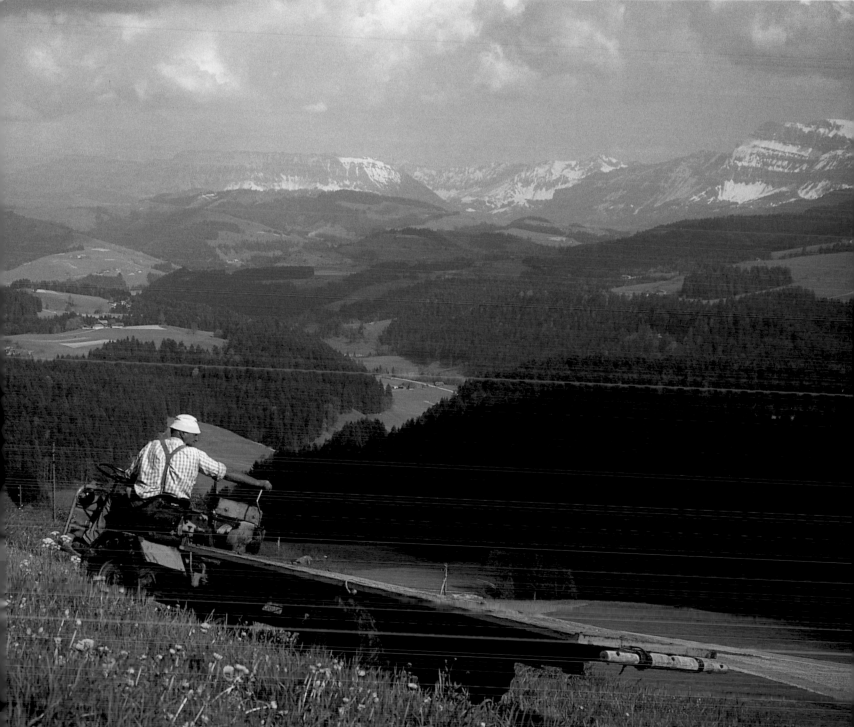

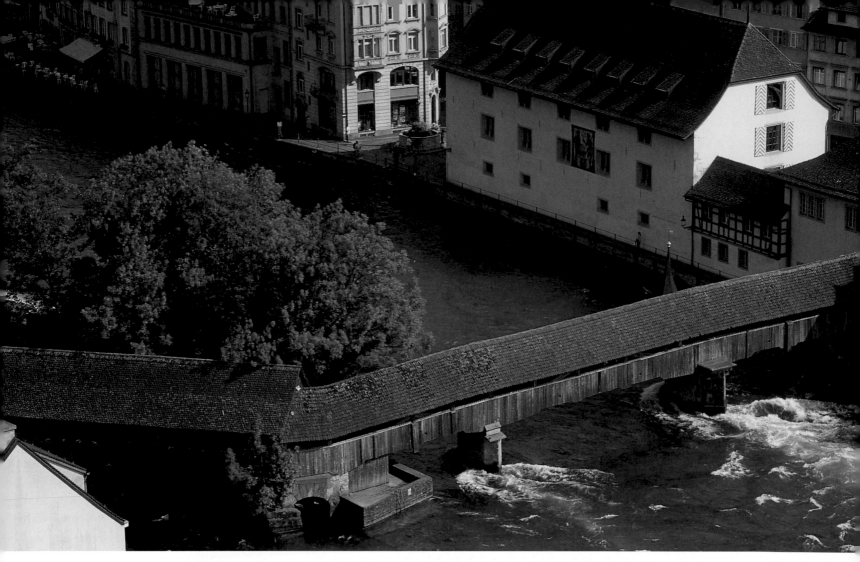

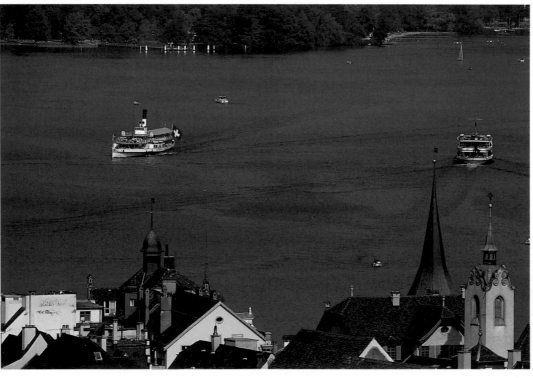

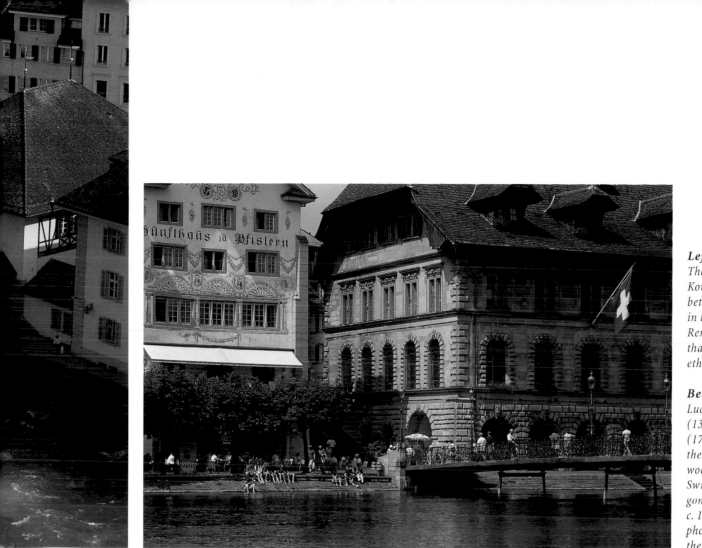

Left:
The old town hall on Kornmarkt was erected between 1602 and 1606 in the style of the Italian Renaissance. Its Swiss thatched roof gives it an ethnic touch.

Below:
Lucerne's Kapellbrücke (1333) is almost 560 ft (170 m) long and one of the oldest remaining wooden bridges in Switzerland. The octagonal Wasserturm from c. 1300 to the left of the photo was once part of the city's fortifications.

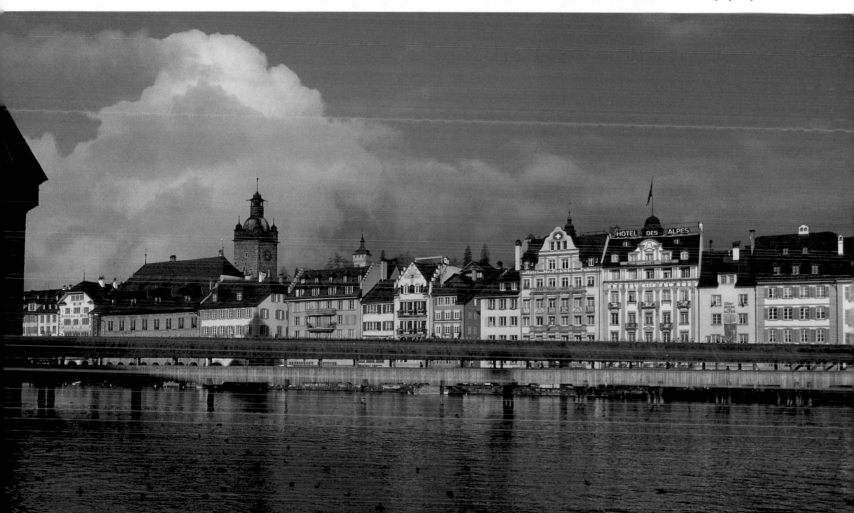

Boarding the William Tell Express at Lucerne, Tell aficionados can take a trip through the St Gotthard Tunnel to Lugano, passing the legendary venues of Switzerland's national myth at the heart of the Confederation along the way. They can idle across Lake Lucerne aboard the Schiller paddle steamer, past the Rütliwiese and Tellskapelle, to Flüelen and on to Altdorf. Although these places were only linked to the Tell saga a good century after the hero's death (in about the 15th century, see p.15), there is much to associate them with genuine historic events from the 13th and 14th centuries.

Legend has it that at the foot of the Rigi, between Küssnacht and Immensee in the canton of Schwyz, tyrant Habsburg governor Gessler was murdered by a rebellious William Tell. The fatal arrow was allegedly fired in c. 1307 from a sunken lane near the chapel named after Tell.

The death of Staufer monarch Friedrich II in 1250 left a power vacuum, prompting religious and secular dignitaries to attempt to extend their territories and secure their own sphere of dominance. The Alps were also affected, in particular the strategic terrain between the sections of the empire north and south of the mountains. These were the areas ambitious dynasties, such as the Habsburgs and the counts of Savoy fought to seize control of. Their overtures met with fierce resistance from towns and village communities not wanting to sacrifice their independence. Uri and Schwyz controlled the ascent to St Gotthard and in 1231 and 1240 respectively were granted permission by the Staufer to self-govern under the Holy Roman Emperor, making them largely autonomous. In 1273, after decades of poli-

Hunter William Tell from the village of Bürglen in Uri enfolds his unharmed son in his arms after shooting an apple off the top of his head (aquatint by Salomon Gessner, 1779).

tical turmoil, Rudolf I of Habsburg was crowned king holy Roman emperor. He strived to strengthen his allodium at the expense of regional struggles for freedom, introduced a rigid system of administration with non-locals in positions of power – such as the governor Gessler in the Tell story – and ruled until 1291. In the year of his death, the farm folk of Schwyz, Uri and Unterwalden formed an alliance, anxious to defend their privileges. The inaugural document of this pact has been preserved and is kept in the same museum as the red banner of Schwyz, to which Rudolf I added a silver cross in 1289, providing the Swiss with their national flag. The Oath of Allegiance is believed to have been sworn on the Rütliwiese meadow on Lake Urn and renewed in 1315 in Brunnen following victory over an army of Habsburg knights.

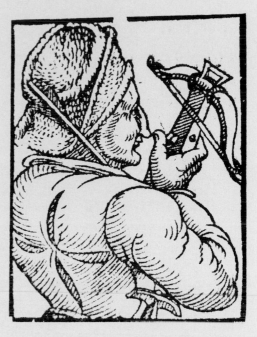

There are countless depictions of Switzerland's national hero, one of them this woodcut from Pantaleon's 16th-century book of heroes.

Over the following decades the Confederation grew, repeatedly warding off the covetous designs of the Austrian Habsburgs. However, loyalties among the Confederates were not particularly strong and in 1440 an internal war broke out over territorial claims made by Zürich on the one side and Schwyz and Glarus on the other. The fighting didn't stop until 1450. In 1474 peace was made with Austria, which now officially recognised the vested interests of the Swiss Confederation. Austria also intervened in the Swiss conflict with the duke of Burgundy, enabling the Swiss to win their battle against the duke in 1477. For a long time, the Confederates were popular allies in the power games played by Europe's rulers. From 1536 to 1798, when Napoleon marched into Switzerland, the Confederation's make-up of the 13 original members and their affiliated towns and villages remained practically unchanged.

The allegory of the apple perched as a target on top of a small boy's head can be found in Nordic sagas from c. 1200, telling of King Harald Blauzahn and the murder of a

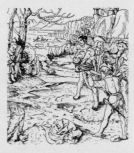

This is one of the earliest known illustrations of an apple being shot off a boy's head. It was executed by Master D.S. in 1507 and included in the »Etterlin Chronicle«.

tyrant. The fired arrow also stands for spring and the repelling of winter and evil spirits. Last but not least, the apple as the forbidden fruit of Christian mythology represents the tree of knowledge. The legend shrouding the founding of the Swiss Confederation is thus drawn from a number of different sources, totally in keeping with Switzerland the multicultural republic.

In the Tell Museum in Bürglen hangs a woodcut by Johann Jost Hiltensperger (1770), part of which is shown in detail here. It pictures the Confederates of Nidwalden seizing the castle of Rotzberg. Nidwalden and Obwalden make up Unterwalden, one of the original three forest cantons, the other two being Uri and Schwyz.

Below:
Opposite the promontory which separates lakes Lucerne and Urn lies Brunnen spa, with Rigi Mountain looming up to the northwest.

Below centre:
At the southern end of Lake Zug is the little town of Arth, whose baroque church dates from the end of the 17th century.

Right:
From Morschach you look out onto Lake Urn, the south section of Lake Lucerne.

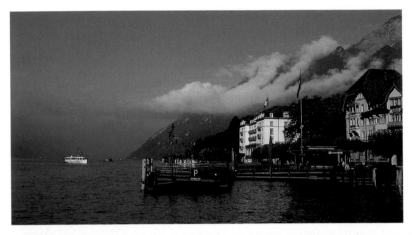

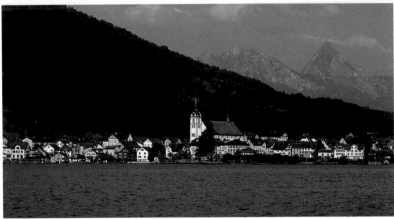

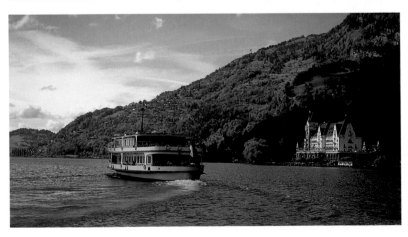

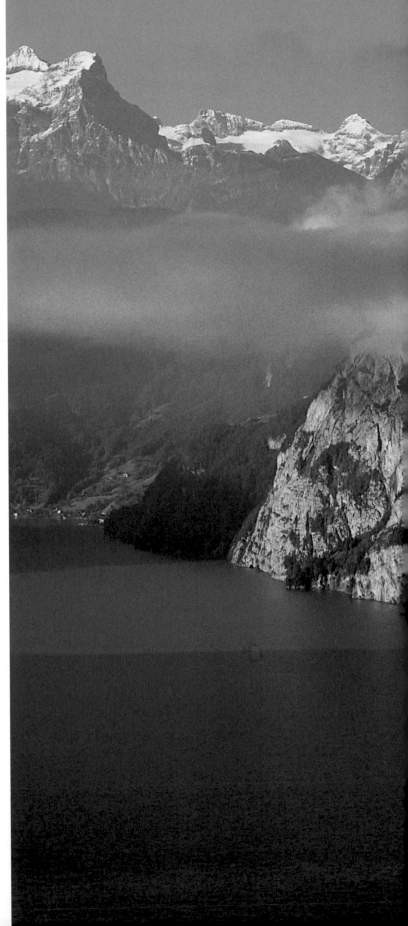

Above:
At Vitznau with its beach on the northern shores of Lake Lucerne, pleasure boats trip across the clear water. Like Arth, Vitznau also has a rack railway shunting passengers up the Rigi.

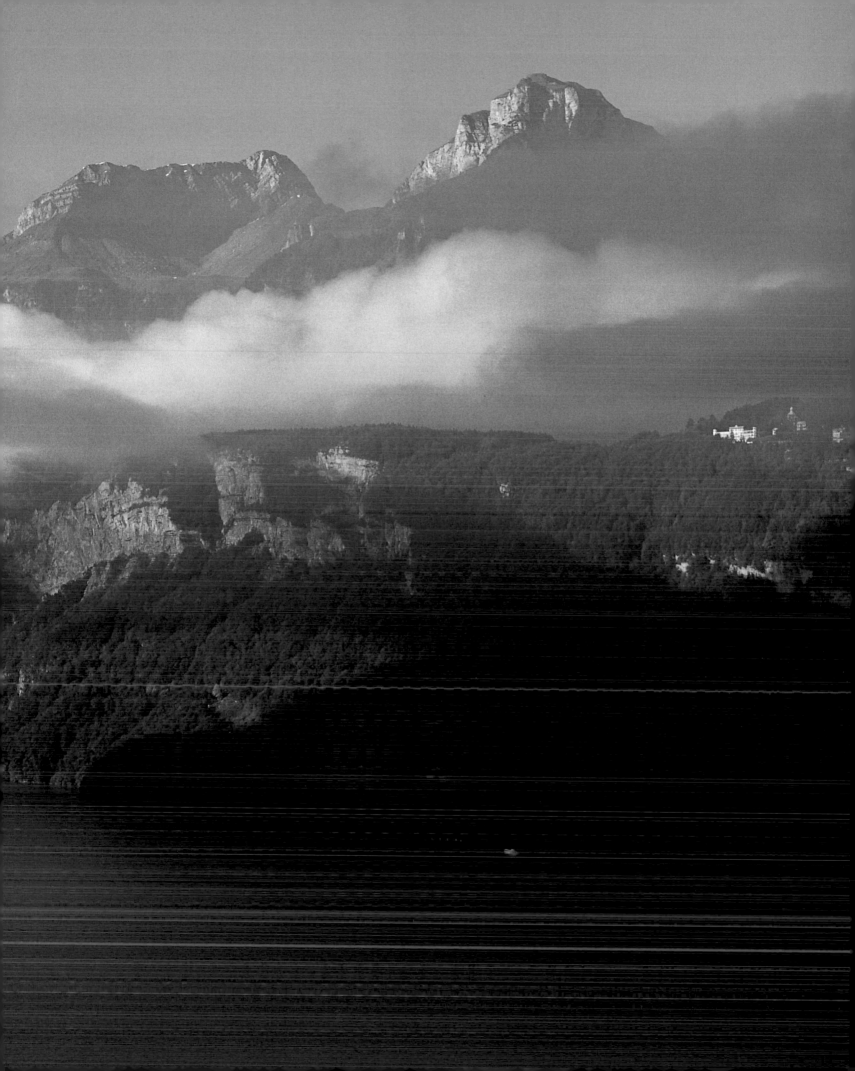

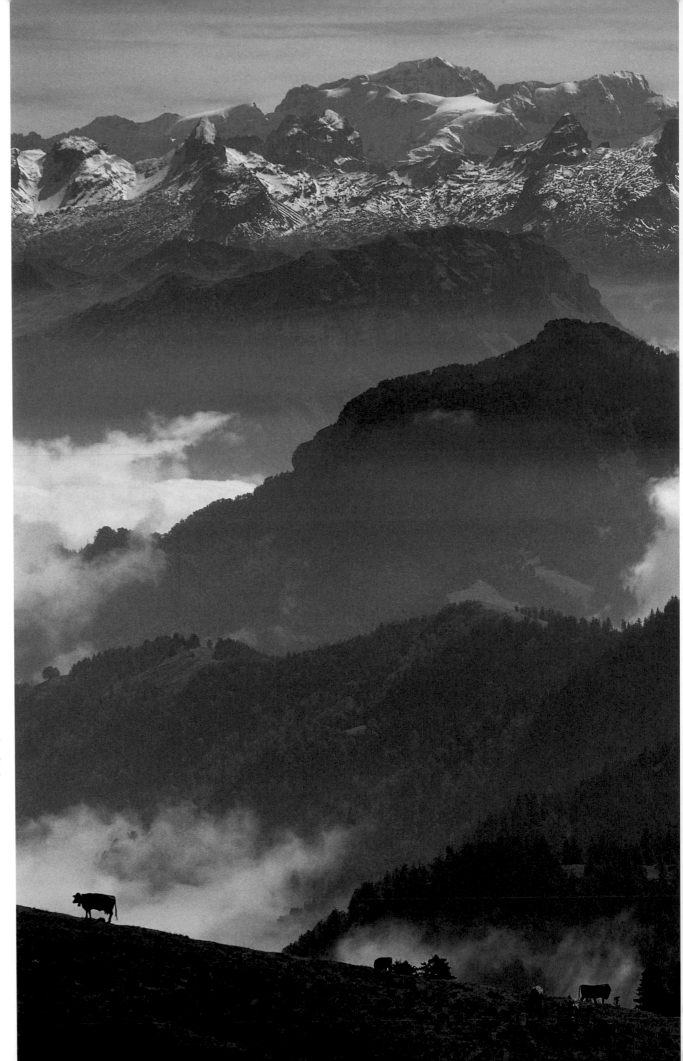

Rigi-Kulm has marvellous views in all directions, here looking southwest to the Bernese Oberland.

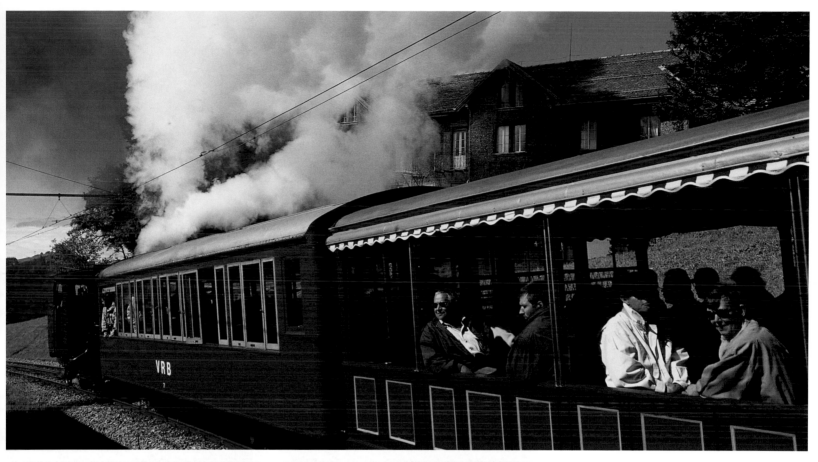

Above:
Vitznau's Rigibahn was the first rack railway to be installed in Europe in 1871. It ascends via Rigi-Staffel (5,269 ft / 1,606 m), covering a maximum gradient of 25%. The line was electrified in 1937.

Left:
The traditional Rigibahn is just one of around 600 mountain railways which play a major role in the Swiss tourist industry.

FROM GRAUBÜNDEN

For many years, the only way to reach the enchanting fishing village of Gandria, perched on the steep slopes of Lake Lugano's Monte Brè, was on foot or by boat.

The most easterly and largest of the canons is crossed by two classic mountain pass routes, one of which runs alongside the Rhine and the other along the Inn. The Albula Pass winds away from the lakes of the high-lying Upper Engadine, with exclusive St Moritz, and on to Davos and Chur. The canton's capital, an old diocesan town with evidence of early Celtic and Roman settlers, once owned prosperous lands which extended as far as the Vinschgau. In order to defend itself against the expansionist Habsburgs, several alliances were formed: the Gotteshausbund (1367), the Oberer Bund (1395) and the Zehngerichtebund (1436). In 1524 the three formed a binding pact, becoming a member of the Confederation in 1803 as Graubünden or Grisons (Grischun in Romansch). One of the characteristics of this region is its linguistic flexibility. Besides German and Italian, Graubünden has five written Romansch languages: Surselvisch (Oberland), Sutselvisch (Central Bünden), Surmeirisch (Oberhalbstein), Vallader (Lower Engadine) and Putér (Upper Engadine). Although it's possible to trace some words back to the Vulgar Latin of the Roman overlords, much of the Romansch tongue remains as indecipherable as the inhabitants themselves.

In Ticino, named after a tributary of the River Po, the main language is Italian. The area between St Gotthard and Lombardy belonged to the duchy of Milan before it was overthrown by the Confederates in the 15th century, serving as a protectorate on the far side of the mountains for 300 years. Through Napoleon's Act of Mediation the territories north and south of Mount Ceneri, Upper and Lower Ceneri, became a canton and an equal member of the Confederation. Long at a severe economic disadvantage, the region grew nearer to Central Switzerland with the extension of the road network. The turn of the 19th century saw an influx of dissidents, artists and tourists, hoping to absorb some of its republican, Mediterranean atmosphere.

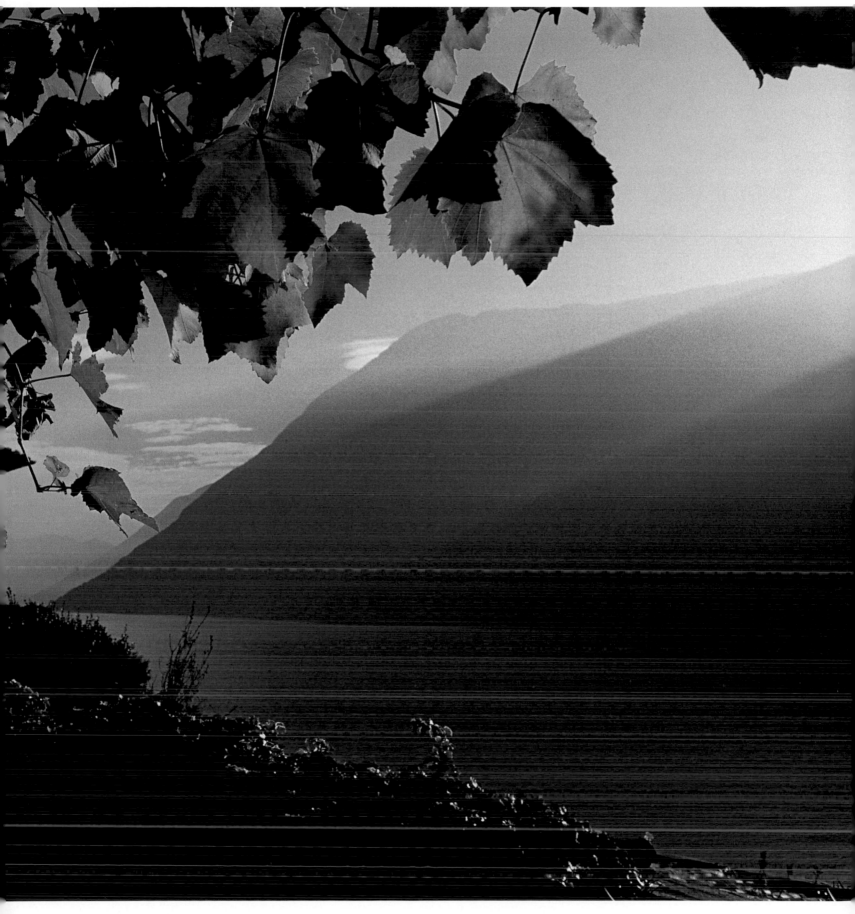

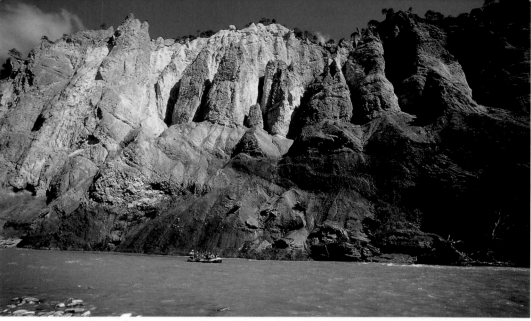

Below:
At only 6,286 ft (1,916 m), Lukmanier Pass is the lowest transit road through Switzerland's Central Alps. It forms the boundary between Graubünden and Ticino.

Right and centre right:
Between Thusis and Splügen, the Lower Rhine first tumbles along the Via Mala and then, south of Andeer, through the Rofla Gorge.

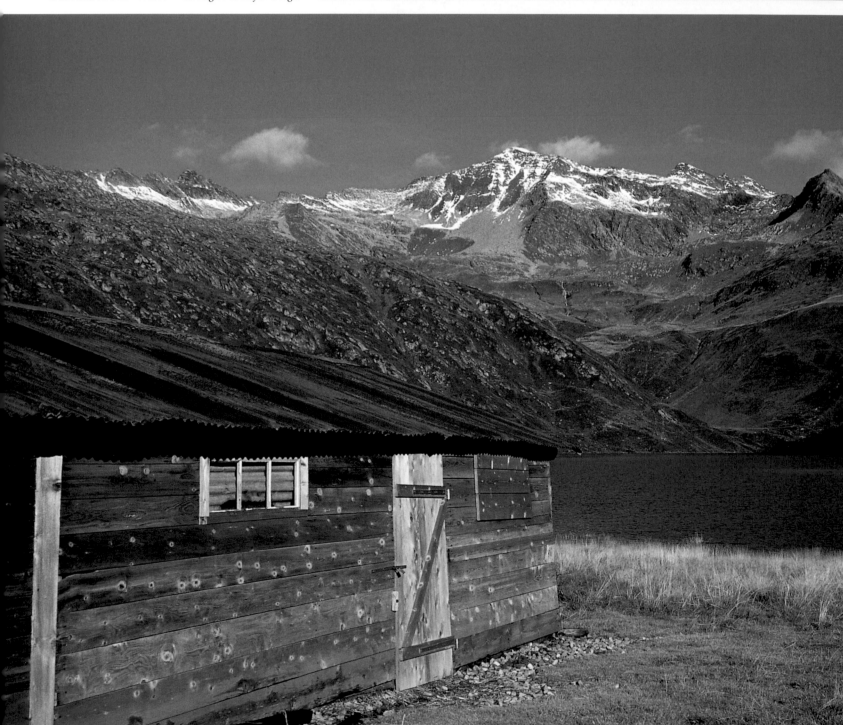

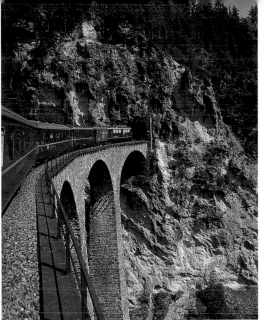

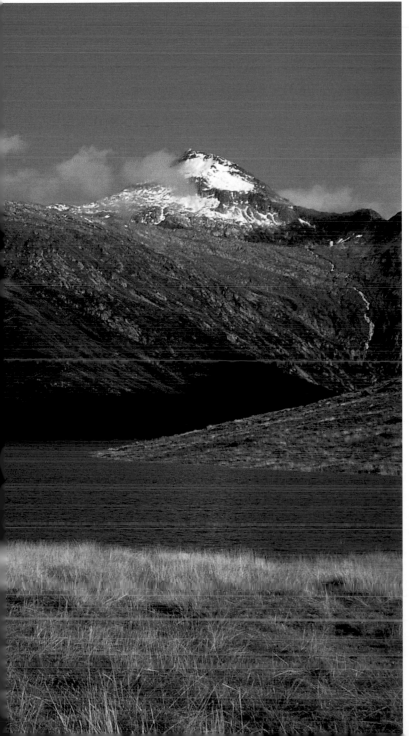

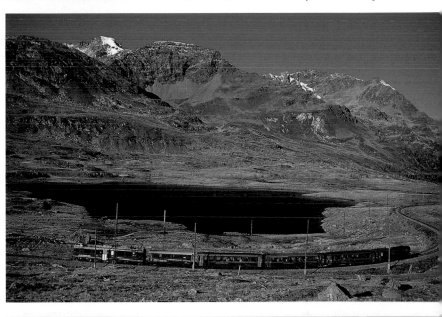

Left:
The Bernina Express takes four hours from Chur to Tirano in Italy. It crosses many viaducts along the way, such as this one at Filisur.

Below:
At the Bernina Pass, the Rhätische Bahn climbs up to 7,405 ft (2,257 m), making this the highest railway line in Europe.

Above:
It's only a short distance from Flims up above the Upper Rhine Valley in Graubünden to the Crestasee.

91

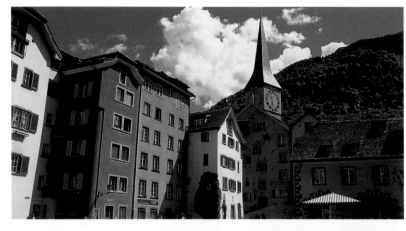

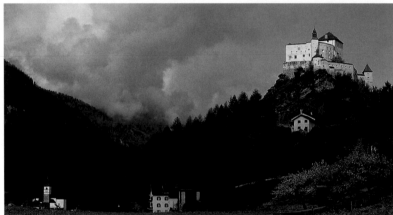

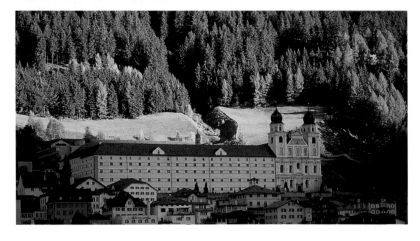

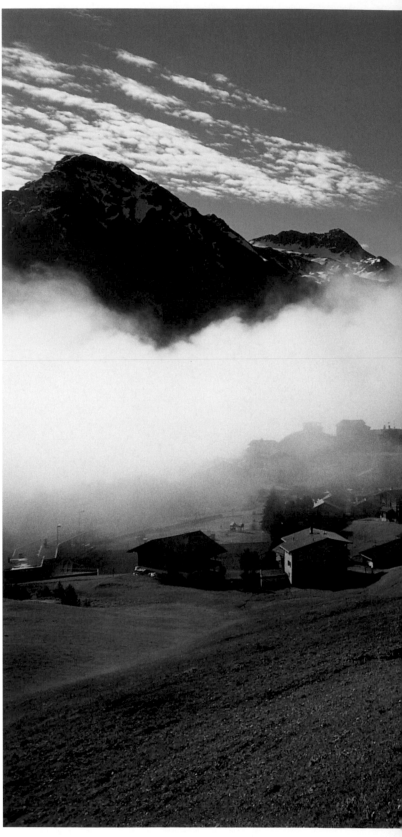

Above centre:
Schloss Tarasp perches on a slate rock on the right bank of the Inn in the Lower Engadine. Built in the high Middle Ages, the castle was completely refurbished in the 16th and 17th centuries. It now features an exhibition on past life in Graubünden and Tyrol.

Above:
There has been a Benedictine monastery above Disentis since c. 720. The present site is a creation from the end of the 17th century, with the church of St Martin from 1712 the perfect embodiment of Vorarlberg baroque.

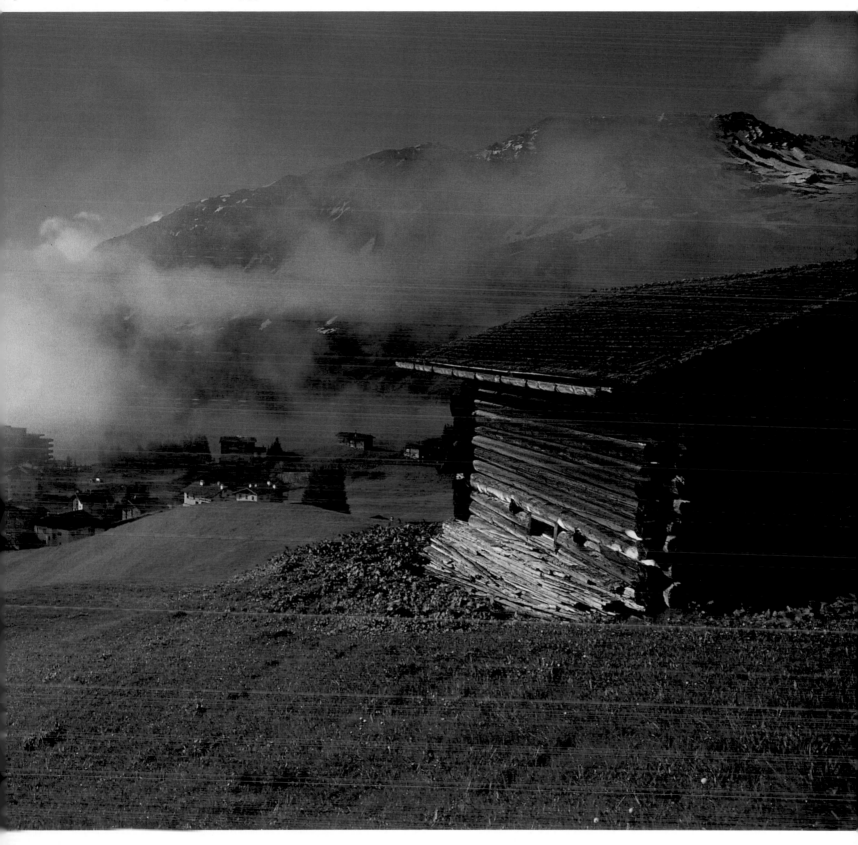

Arosa is a good 19 miles (30 km) from Chur, squeezed in between the mountainous high valleys of the Schanfigg.

Page 94/95:
The east face of Piz Bernina (13,284 ft / 4,049 m).

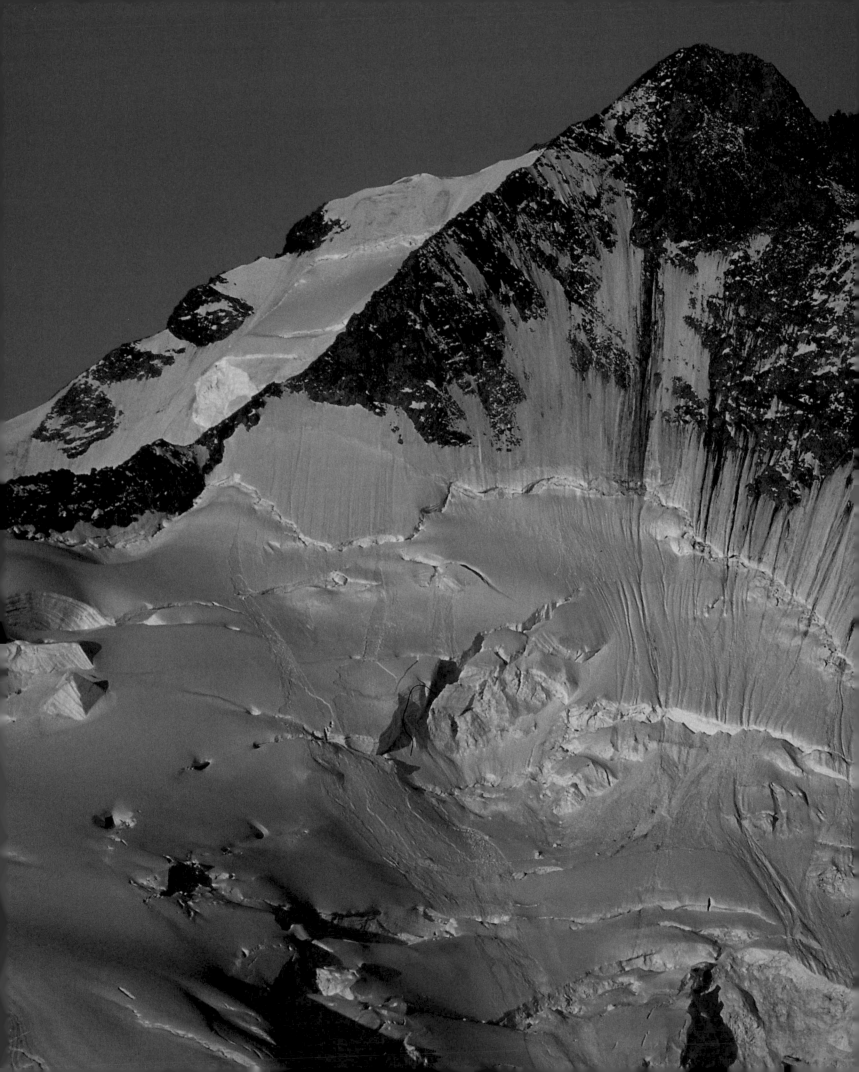

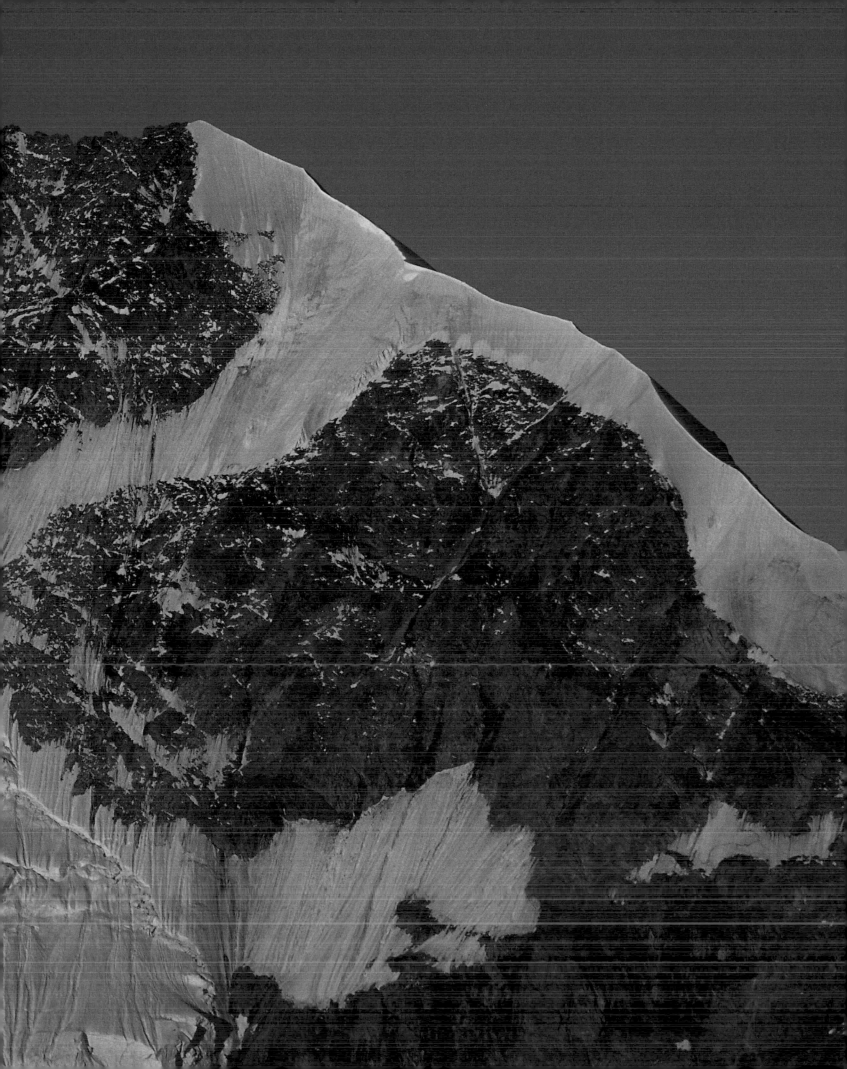

WHERE THERE'S A WILL...

Around 60% of Switzerland's good 15,000 square miles (40,000 square kilometres) of surface area is in the Alps. The Bernese, Valais and Rhatian Alps climb up to an incredible 13,000-plus ft (over 4,000 m), with the highest point in the land, Monte Rosa, a staggering 15,204 ft (4,634 m). Yet both the lower-lying regions, such as the northern foothills, and the higher Alpine areas are excellently served by roads and railway lines.

Even before the Romans numerous routes lead through the small and often almost inaccessible mountain regions. Celtic Helvetii were the first to settle between the Jura Mountains and the Alps. They were followed by the Romans, who gradually annexed ever larger stretches of Alpine terrain, turning paths and steep tracks into Roman roads affording access to their northern provinces. After the fall of Rome, the Alemanni began to spread out across what is now eastern Switzerland, with the Burgundians to the west. This tribal movement created a network of transit routes.

To reach destinations by the most direct route and to save time, higher-lying cols were also used, one of the oldest and most important being the Great St Bernard Pass which runs up to 8,100 ft (2,469 m). It links the Po Basin to the northwest with the Rhône Valley and the Upper Rhine Valley and was used as long ago as in the 6th and 5th centuries BC (the late Iron Age). Emperor Augustus had a track laid from Aosta to Martigny and dedicated the pass to the heathen Roman god Jupiter Poeninus, whose name lived on for a time in Vallis Poenina, the valley of Poeninus, now Valais. At the highest point was the holiest sacrament of all the Alpine passes, to which travellers paid homage for almost a thousand years. Some of the offerings left here are on display at the hospice museum. The present name of the pass comes from St Bernhard of Mentone who founded the hospice in the 11th century.

Another ancient Alpine thoroughfare ran from the Lake Maggiore area and Lake Como in the direction of Lake Constance, through the Engadine and Inn Valley via the Septimer Pass (7,546 ft/2,300 m) and later also the Maloja (5,955 ft/1,815 m) and Julier passes (7,494 ft/2,284 m). The route via the San Bernardino (6,775 ft/2,065 m) and Splügen passes (6,933 ft/2,113 m) to Chur was less frequented, as it involved negotiating the impressive yet (at that time) dreaded canyon of the Lower Rhine, the Via Mala, on foot. A road – only marginally less terrifying – wasn't built here until 1471. For our Swiss ancestors, the high mountain passes were a far less daunting prospect than the impenetrable, perilous gorges and clefts. One of these is the Schöllenen Gorge north of the Gotthard between Göschenen and Andermatt. At the end of the 13th century, when a »Devil's bridge« was built across the River Reuss and a steep path carved up the gorge, the mule track across the St Gotthard Pass (6,916 ft/2,108 m) was finally attainable. This opened up a new international route of trade, forging a link between the upwardly mobile cities of Italy and the Hanseatic strongholds of the north – and knocking several days off an otherwise extremely tedious journey.

Among the dozens of Swiss Alpine passes, the one which literally sticks out above the rest is the Umbrail Pass in the Ortler Alps, at 8,206 ft (2,501 m) the highest of them all. The road winding up 34 bends and 8 miles (13.5 km) from St Maria was built in 1901 and leads back down into Valtellina in Italy. The first »modern« Alpine highway, a grand 39 miles (63 km) long, was erected by Napoleon across the Simplon Pass (6,578 ft/2,005 m) between 1800 and 1805, providing him with a through route to Lombardy. The first half of the 19th century saw the construction and extension of a number of pass roads, among them the St Gotthard (1829), the Maloja (1828), the Julier and Splügen (1824) and the Bernardino (1823). Roadways were built across the Albula (7,595 ft/2,315 m) and Bernina (7,402 ft/2,256 m) in 1865.

MOUNTAIN PASSES AND TUNNELS

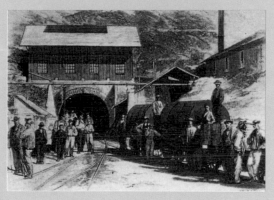

The construction of railway lines through the Alps was greatly accelerated by the invention of dynamite in 1867. In 1882 the full 9 miles (15 km) of the St Gotthard Tunnel were opened. This was followed by the Simplon Tunnel in 1906, which together with the Lötschberg Tunnel of 1913 is the quickest way of getting from Milan to Bern. Today, around 3,000 miles (5,000 km) of track criss-cross Switzerland. One particularly spectacular local network is that of the Rhätische Bahn, which with its Glacier Express takes in some breathtaking scenery. It climbs up to almost 8,202 ft (2,500 m), covers 181 miles (291 km), crosses 291 bridges and passes through 91 tunnels from St Moritz to Zermatt.

Louis Favre, chief engineer of the St Gotthard Tunnel, died during construction work on the tunnel, as did 176 others.

The first road tunnel in the western Alps is that under the Great St Bernhard, opened in 1964 and 3.5 miles (5.8 km) long. In 1967 came the San Bernardino Tunnel (4 miles/6.6 km) between Splügen and Mesocco and in 1980 the St Gotthard Tunnel as the then longest tract of covered road in the world at a lengthy 10 miles (16.8 km). With the opening of the Rigi Bahn (5,738 ft/1,749 m) in 1871, the first mountain railway in Europe, mountain access entered a new dimension. Since 1912 there has even been a train running up the inside of the north face of the Eiger to the Jungfraujoch at a giddy 11,342 feet (3,457 m). Hundreds of rack railways, cable cars and chair lifts enable just about everybody to enjoy the stupendous panorama of jagged Alpine peaks, stretching out as far as the eye can see and seduce many into underestimating the dangers of and damage which can be done to this fantastic part of Europe.

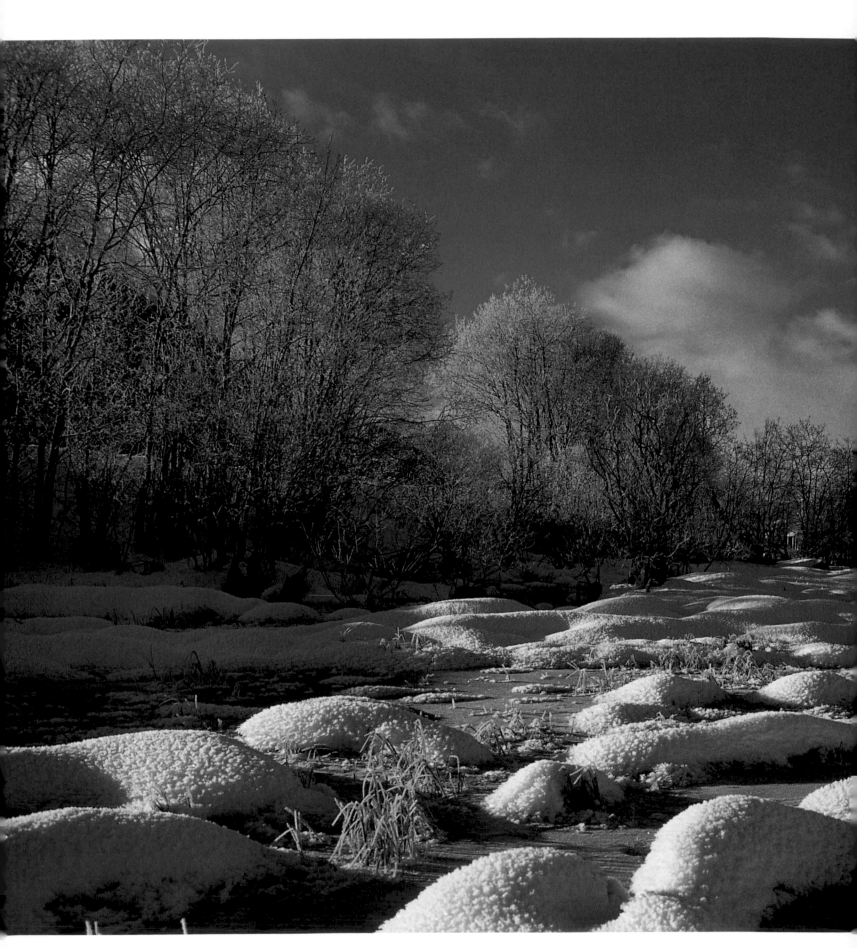

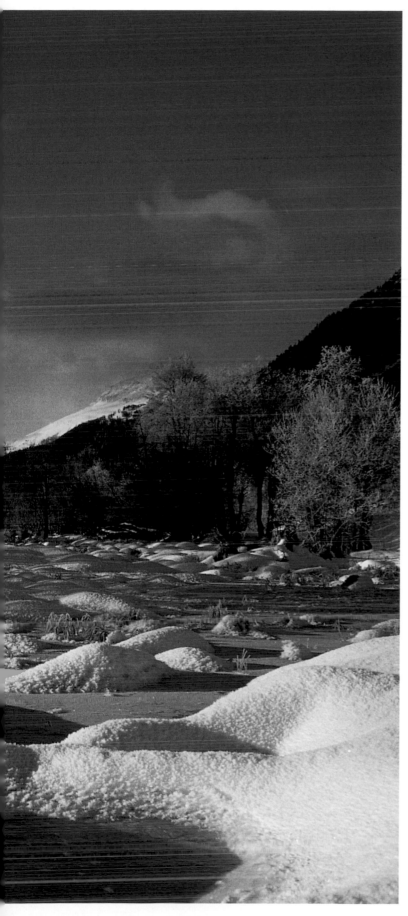

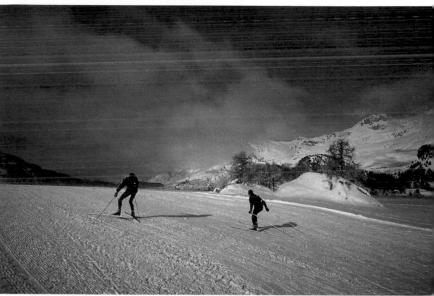

Far left and left:
Captivating landscapes at La Punt in the Upper Engadine Valley and at the Heidsee near Lenzerheide.

Below:
Seventh heaven for cross-country skiers on Lake Sils just beneath the Maloja Pass.

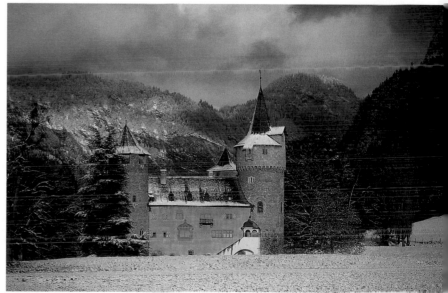

Above:
Schloss Marschlins defends the entrance to the Prättigau area east of the Rhine. The 13th-century moated castle was revamped in the 17th and 18th centuries.

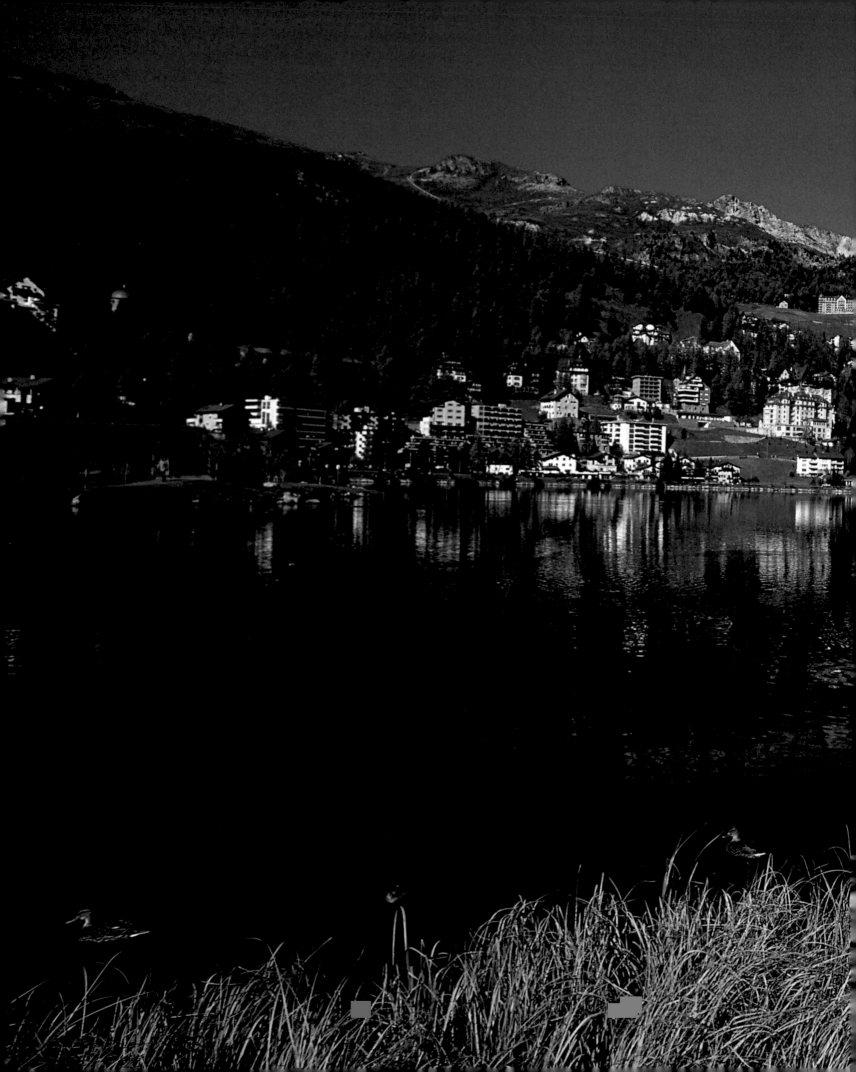

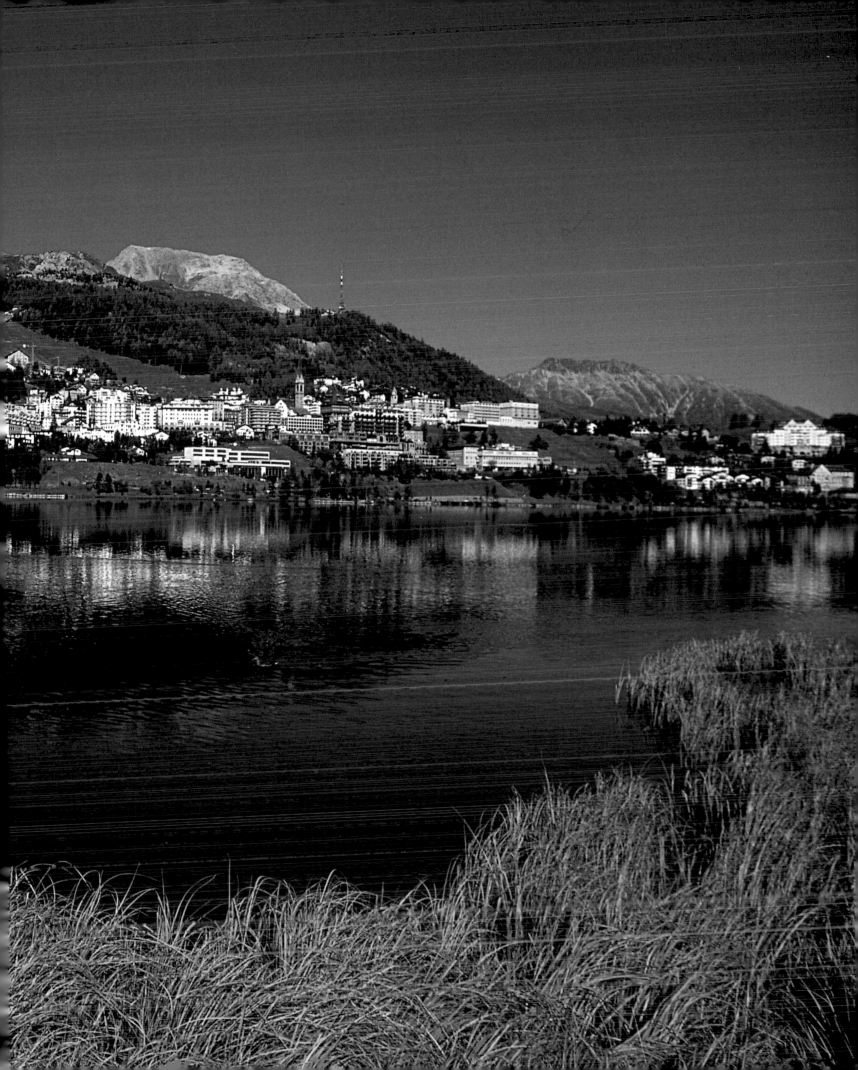

Page 100/101:
Lake St Moritz, through which the River Inn flows, is 5,800 ft (1,768 m) above sea level. At the southwestern end is the spa of the same name, famous for the healing properties of its carbonated ferruginous springs discovered during the Bronze Age.

Right:
Detail of the sgraffitoed Clalgüna Haus in Ardez in the Lower Engadine Valley.

Below:
In the Val Bregália between the Maloja Pass and Chiavenna, the road running alongside the Mera River cuts off to Soglio just before the national border.

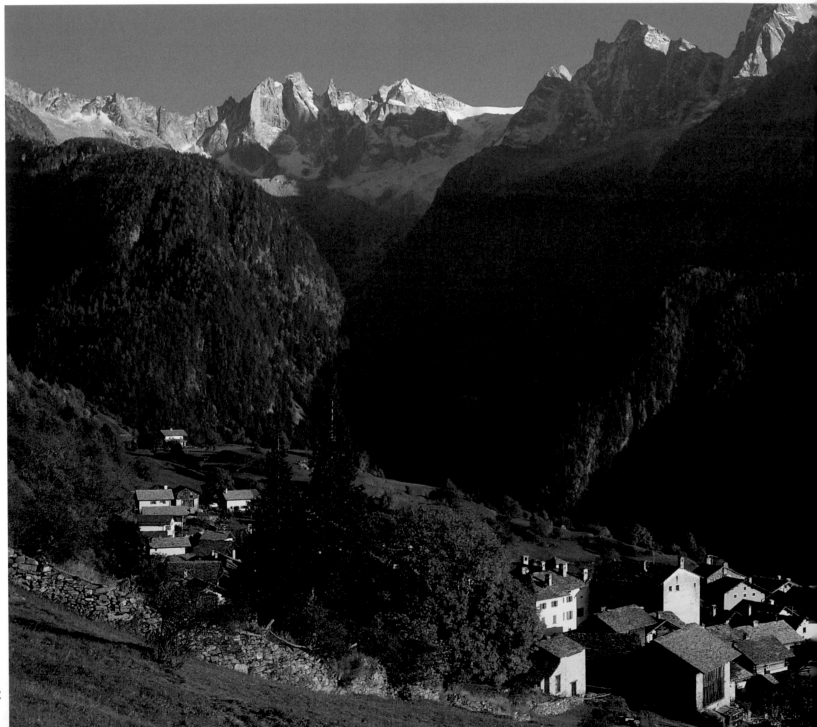

Left:
Going to Zuoz, once the county town of the Upper Engadine, is like stepping back in time, with the old-fashioned architecture of its houses and towers.

Below:
Examples of typical Engadine building styles can also be found in Guarda, where the farmhouse and barn, their façades boldly ornamented, are both under one roof.

Below centre and bottom:
Soglio, formerly the seat of the House of Salis, is girdled by a forest of chestnut trees which extends as far as Castasegna on the Italian border. The harvest of these nutritious fruits is as big a tradition as the trough at the heart of the village, where locals still occasionally do their washing.

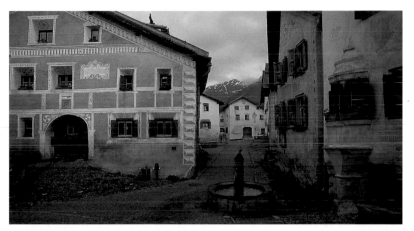

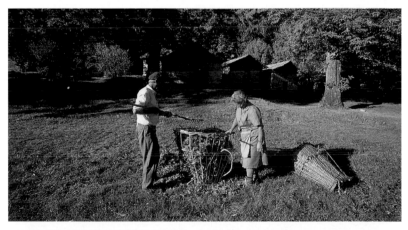

Page 104/105:
Bellinzona's Castello Grande from the 13th century, lit up in full splendour. Once the Confederates had seized control of the town, it became the residence of the governors of Uri.

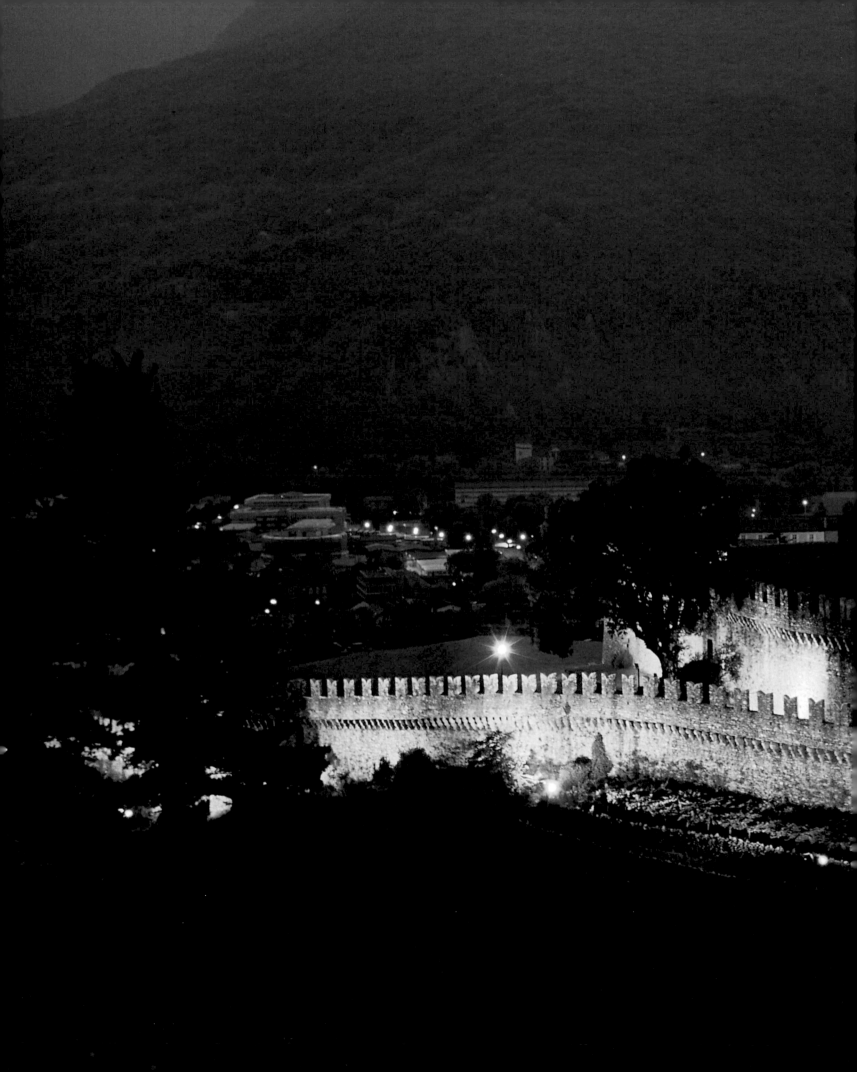

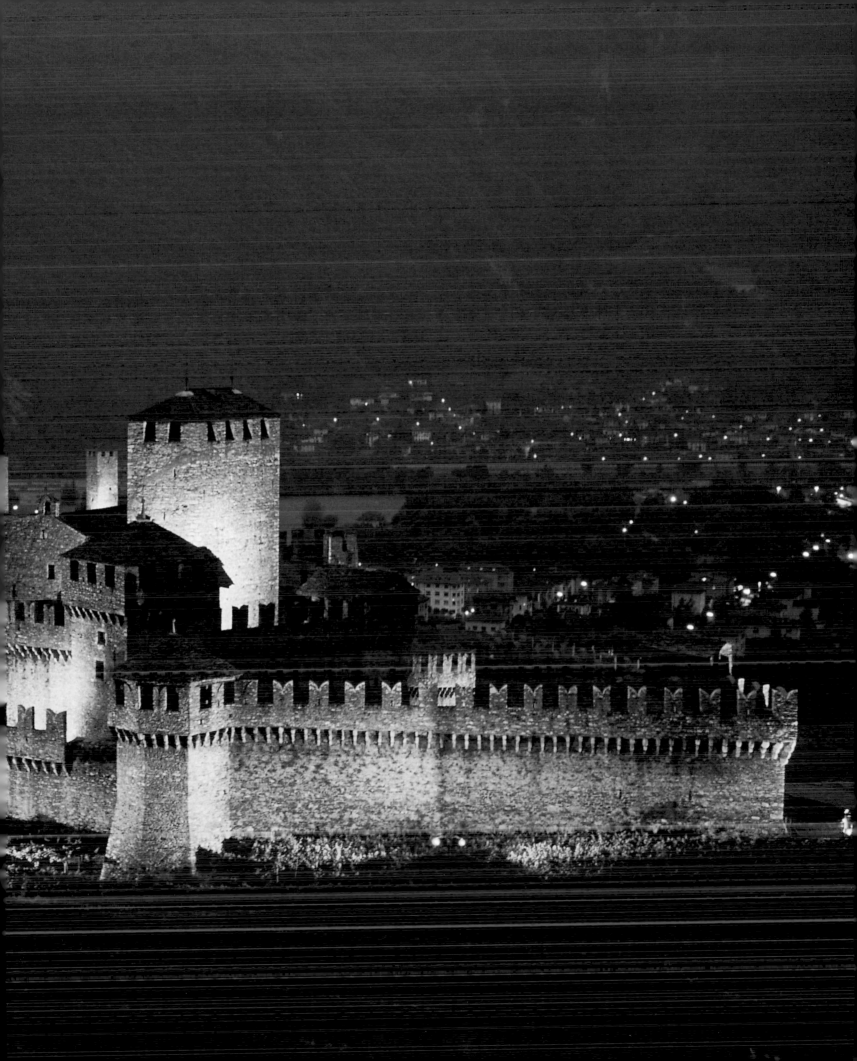

Below:
Across from Locarno at the northern end of Lake Maggiore, Magadino seems almost cosmo- *politan, perhaps a legacy of the days when it was a centre of trade serving both land and water.*

Right:
The mooring near Magadino, abandoned in the orange twilight.

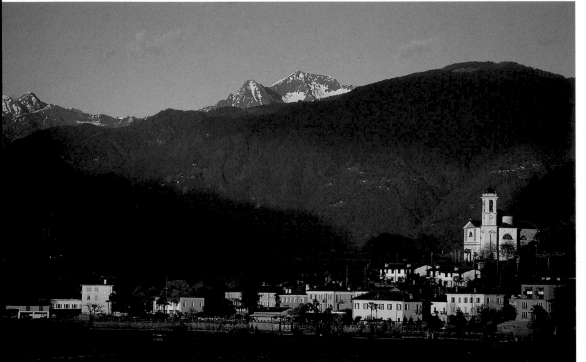

Above:
Vira's parish church of San Pietro, originally 8th century, was *completely redesigned in the 18th century.*

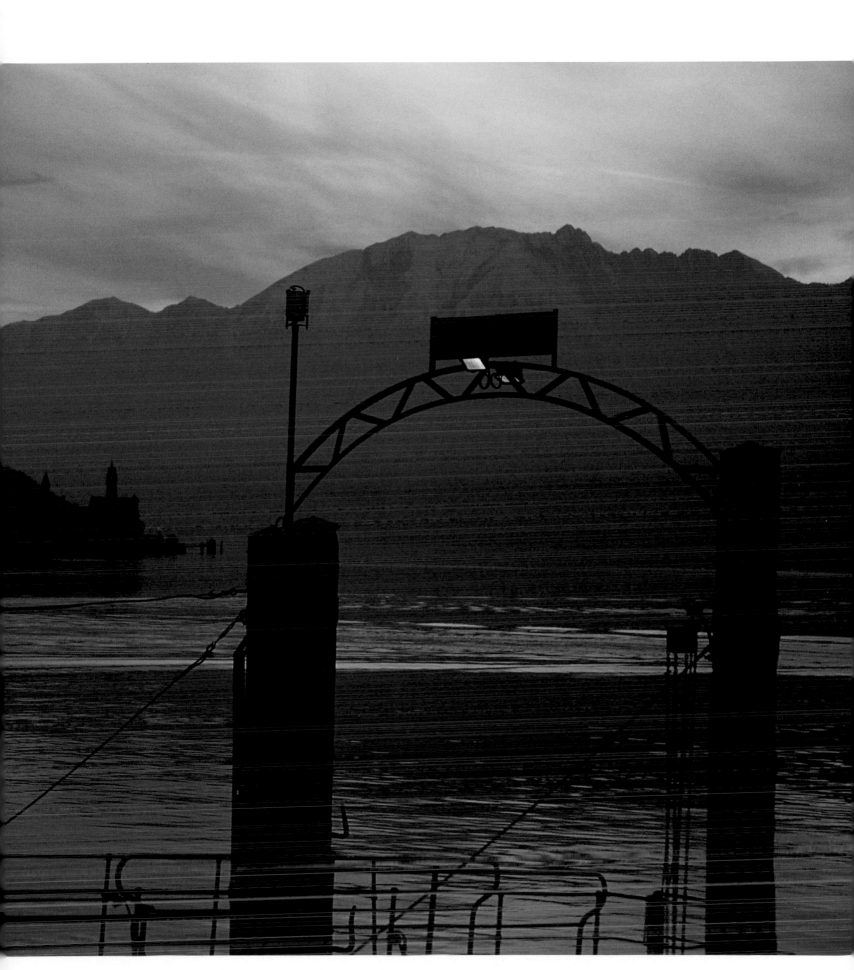

Below:
The Piazza Grande at the core of Locarno is probably one of the most beautiful squares in the whole of Ticino. It was given a complete makeover in the 19th and 20th centuries.

Below:
One of the sloping narrow streets in Locarno's old town, with the sanctuary of Madonna del Sasso peering through the roses in the background.

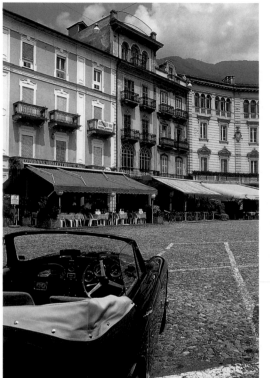

Below:
Encouraged by the mild Lake Maggiore temperatures, la dolce vita is often lived out on the streets at night, such as here in Locarno.

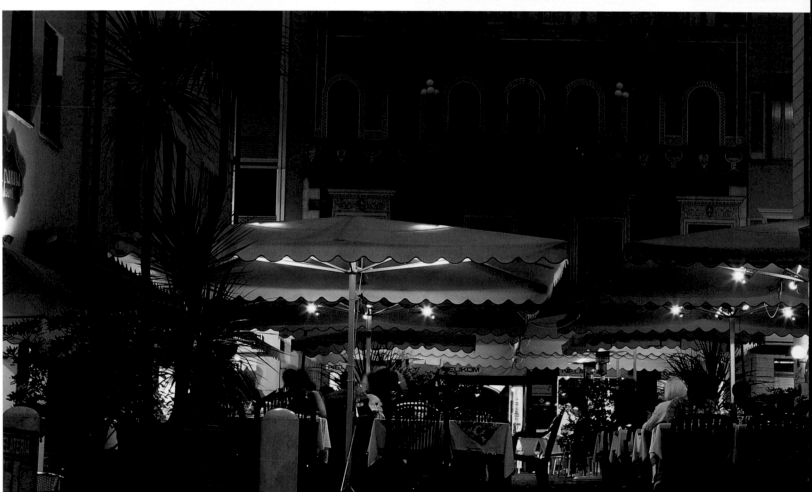

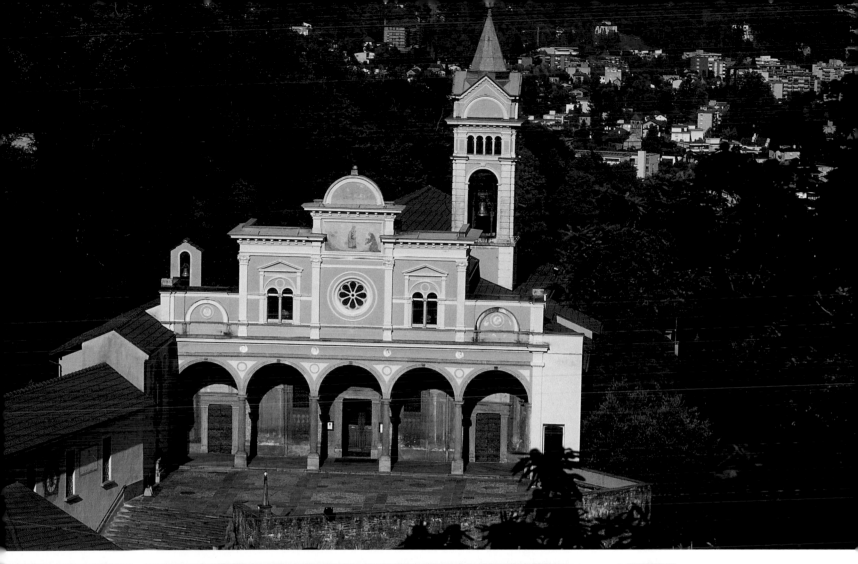

Above:
Madonna del Sasso solemnly surmounts its wooded outcrop high up above the town. Founded in 1480, the church and Capuchin monastery were completely rebuilt in 1616.

Left:
All kinds of exotic and native plants thrive in the subtropical, Mediterranean climate of Ticino. Harvest time is the ideal excuse for a party, such as here in Locarno, which celebrates its Castagnata or chestnut festival in late autumn.

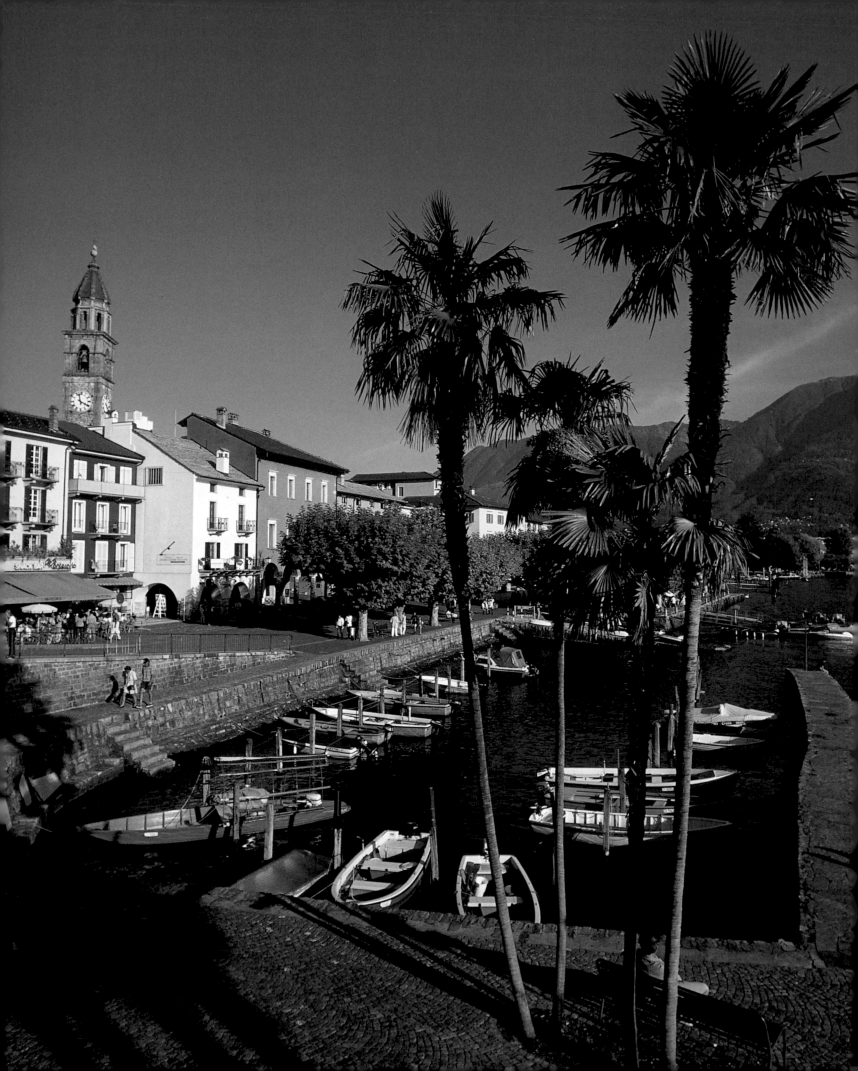

Left:
The clock tower of the parish church of SS. Pietro e Paolo looms large behind the lakeside promenade in Ascona, lined with palm trees.

Below:
On the larger of the two Brissago Islands, San Pancrazio, an elysian botanical garden draws thousands of plant enthusiasts from April to November.

Below:
No Mediterranean holiday would be complete without the street artist, surrounded by a crowd of curious onlookers.

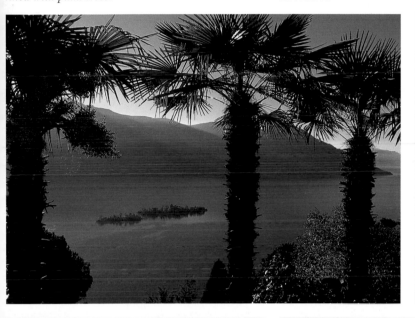

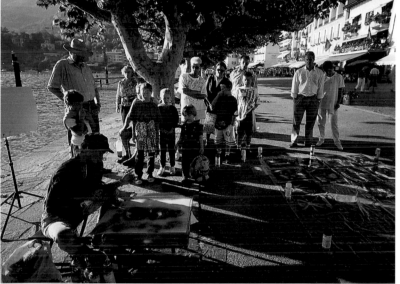

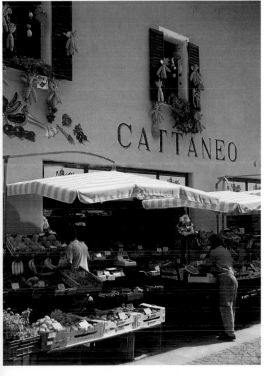

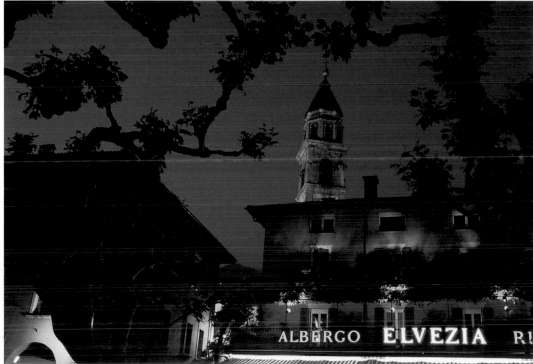

Above and above right:
The foodstores scattered around the old town of Ascona are paradise for connoisseurs. And that famous flair which placed Ascona firmly on the holiday map in the 1960s is still very much in evidence.

111

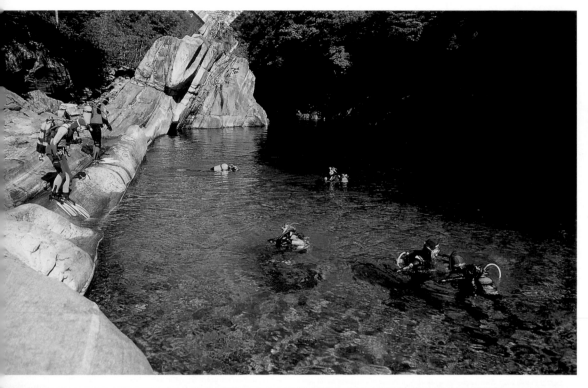

Right:
Near Intragna in
Centovalli, the valley of
a hundred valleys, the
Ponte Romana arches
over the river.

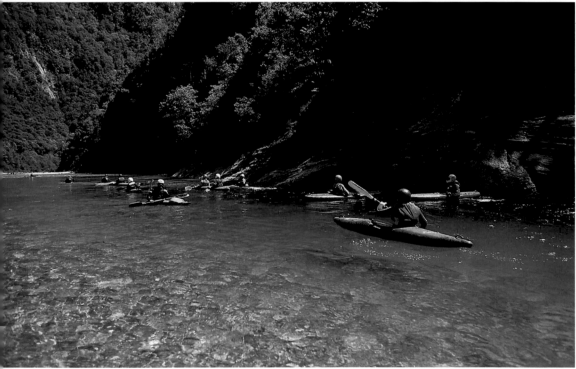

Above and top:
The rivers of the Ticino
Alps, here the Verzasca
(top) and the Maggia

(above), are popular
with divers, canoeists
and nature-lovers alike.

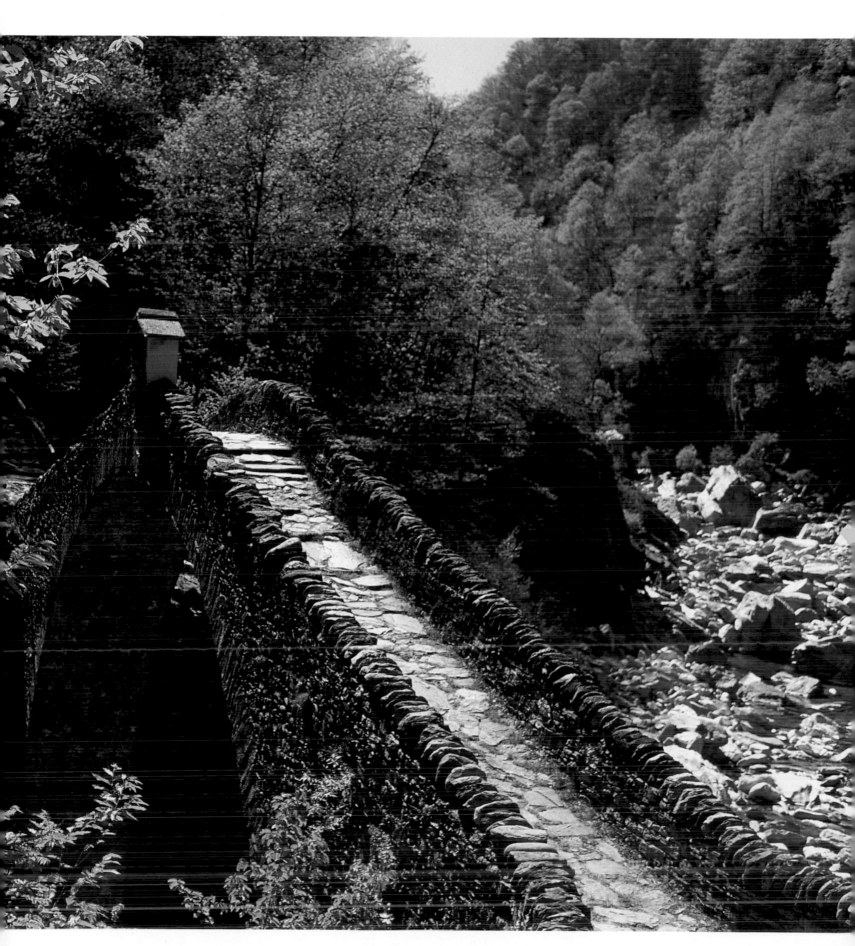

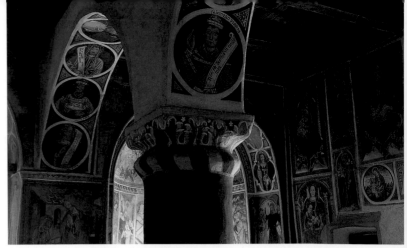

Below:
The little town of Giornico straddling both sides of the Ticino River was inhabited by the Romans. During the high Middle Ages it was a major ecclesiastical centre. Besides its six churches and chapels, Giornico also has some very old stone houses worth investigating.

Right and far right:
San Carlo near Negrentino is one of Switzerland's most significant Romanesque churches containing valuable Romanesque and Gothic frescos. The oldest parts of the building, easily distinguishable with its two apses, are 11th-century.

Below and below centre:
In more out-of-the-way places, such as Corippo (below centre) and Foroglio in the Val Bavona (below), the stone houses illustrate the traditional building methods employed in the mountain villages of Ticino.

Bottom:
The wayside shrines erected by devout locals near the abandoned village of Boschetto near Cevio mostly serve to remind stray tourists of the transience of life.

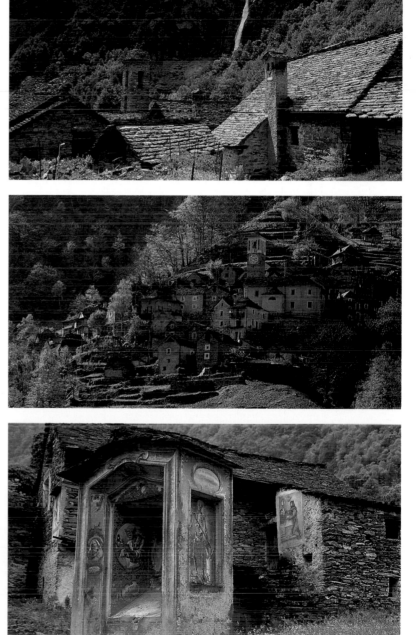

Page 116/117: Exclusive views of Lugano, which as the largest town in the canton of Ticino has risen to become a centre of the national economy and world of finance.

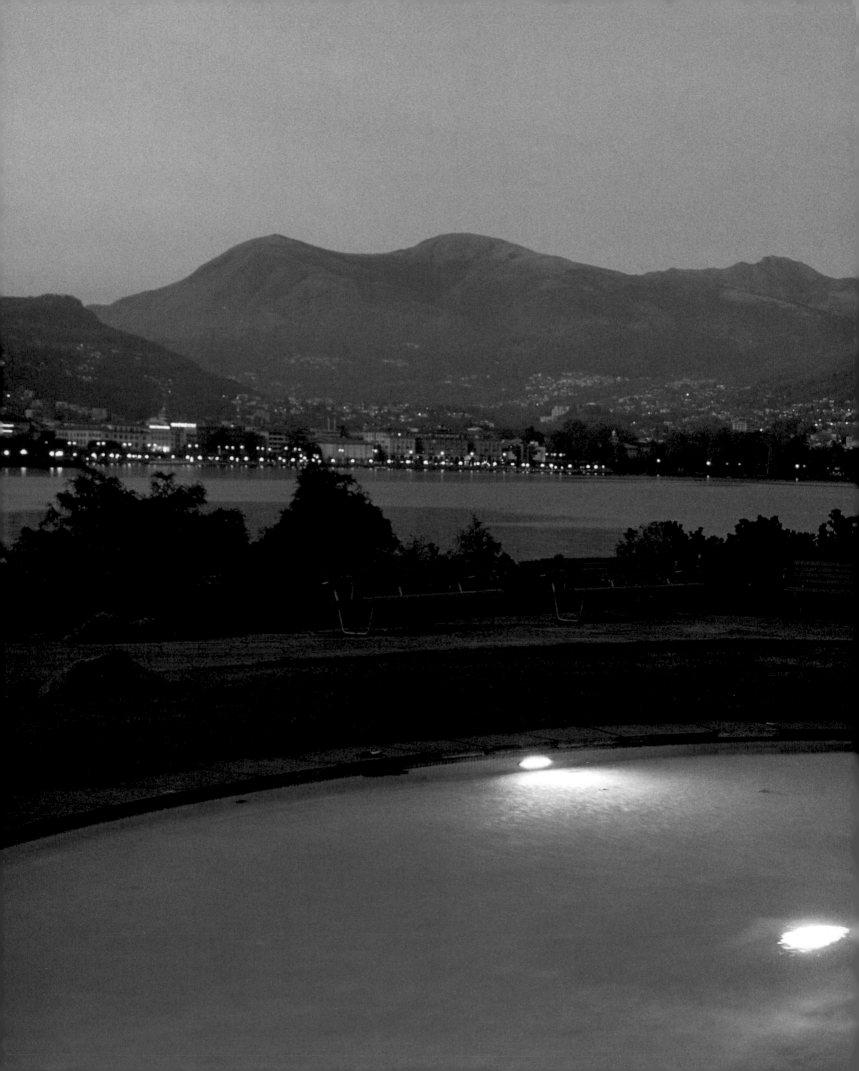

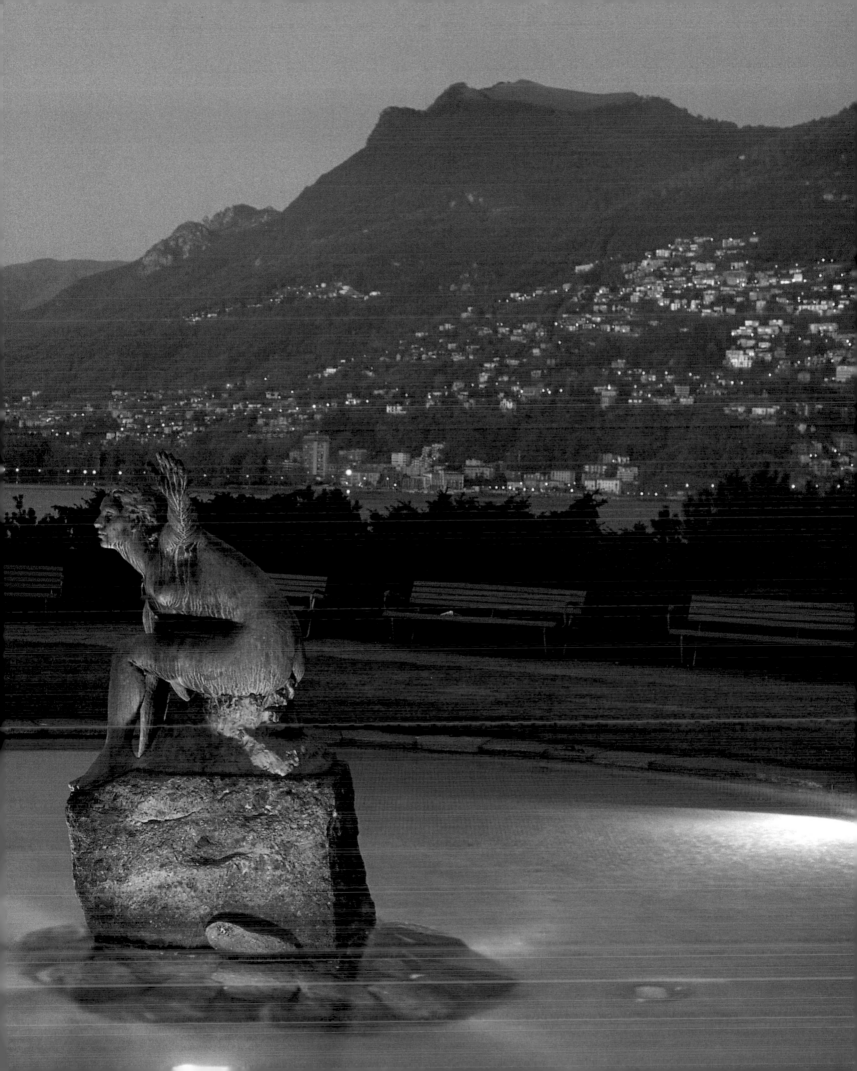

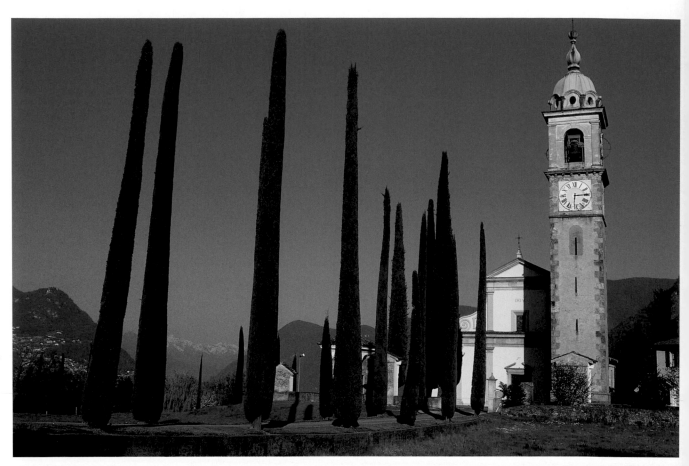

Far right:
The chapel dedicated to San Antonio Abata in Morcote is medieval in origin, with frescos from the 15th century.

Right:
The San Abbondio complex near Gentilino is a charming ensemble of architectural elements from the 16th and 17th centuries. The free-standing campanile almost overshadows the aisled church.

Right:
The Villa Favorita in Lugano-Castagnola has one of the best private art collections in Europe, that of Thyssen-Bornemisza.

Page 120/121:
Lake Lugano may not be able to compete with its Upper Italian neighbours for size, yet its unforgettable, sheltered location makes it one of the top beauty spots in southern Switzerland.

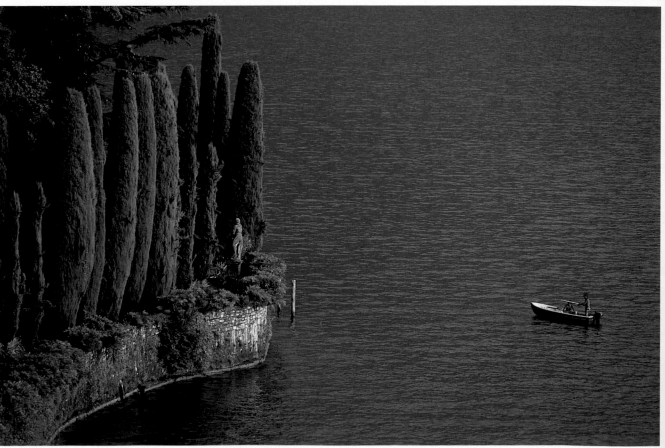

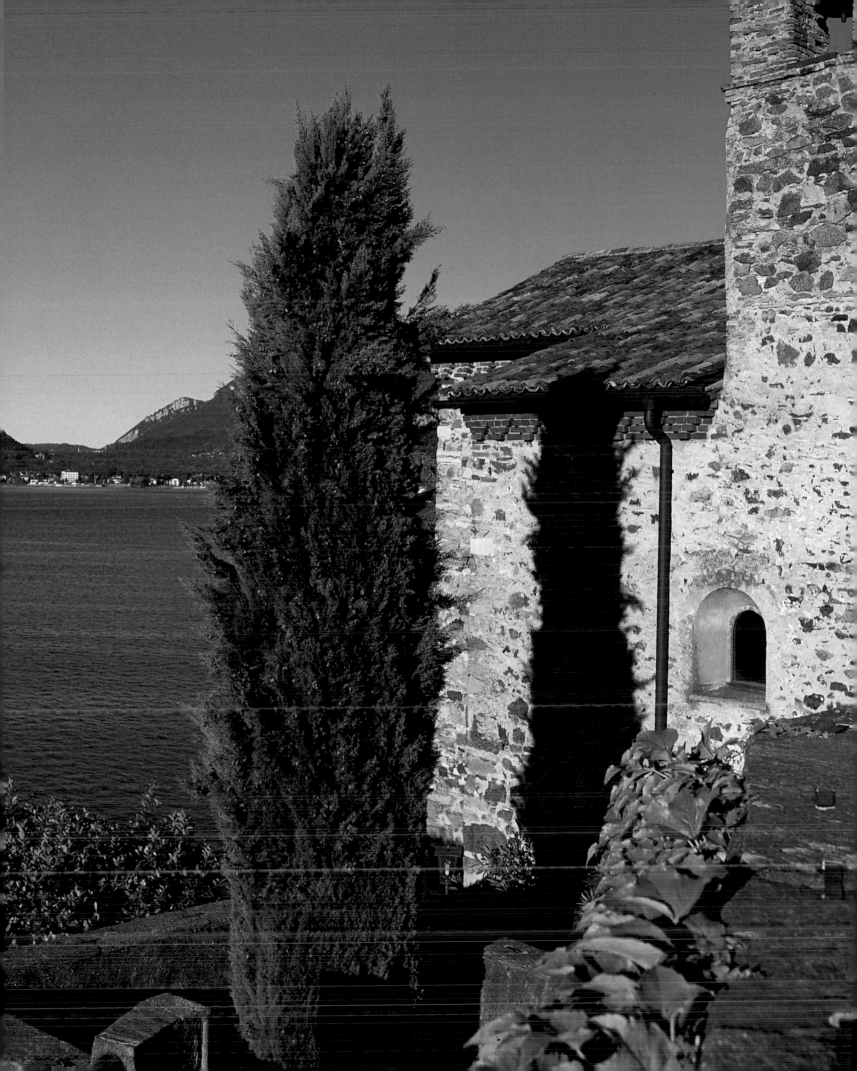

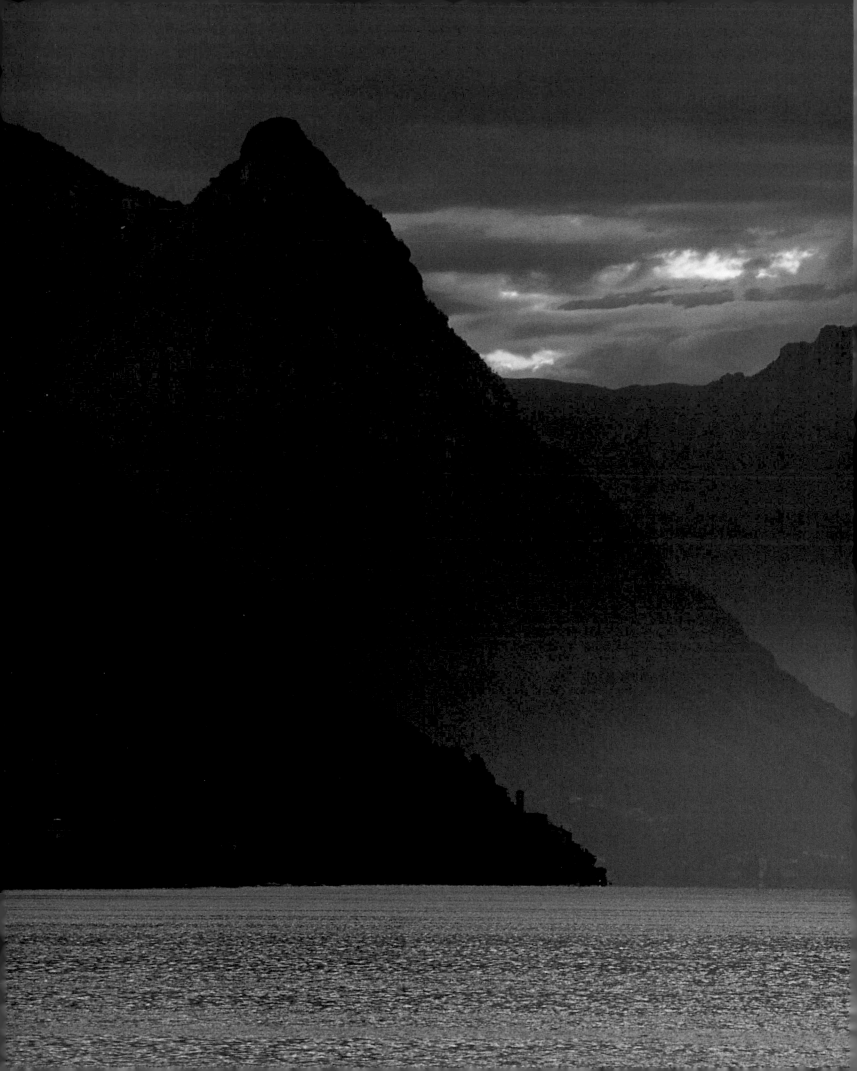

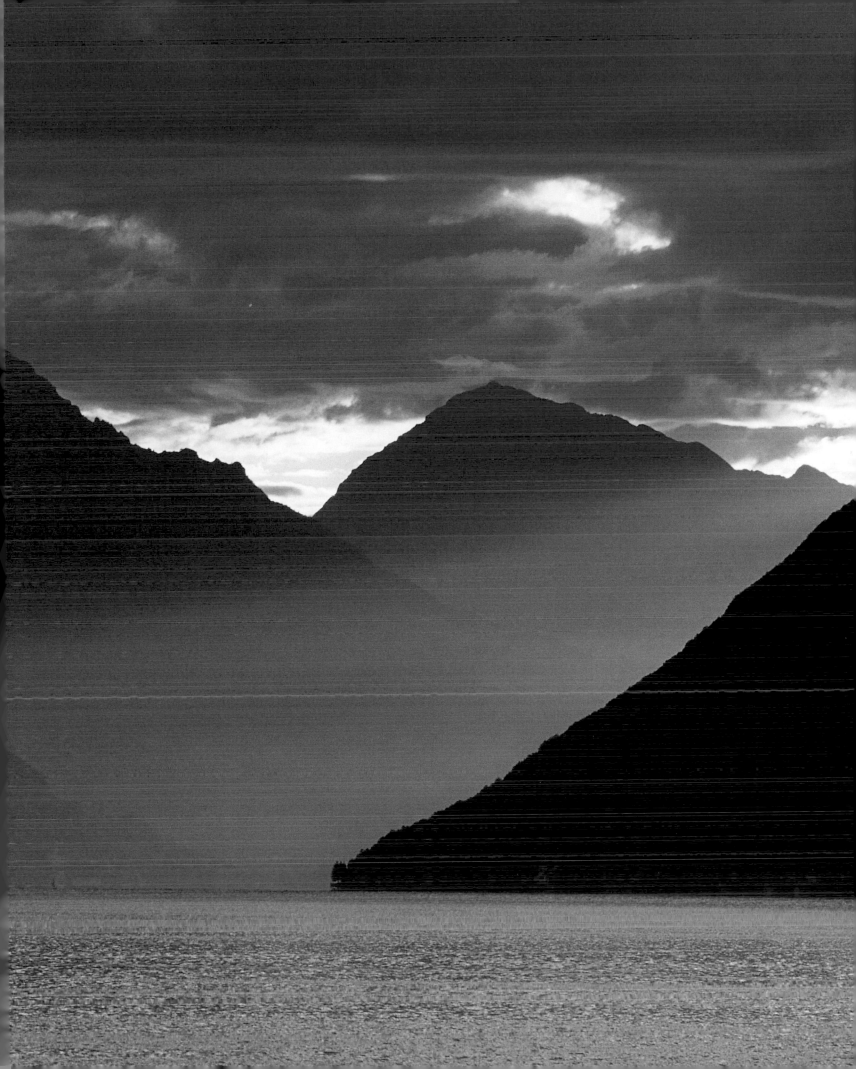

INDEX

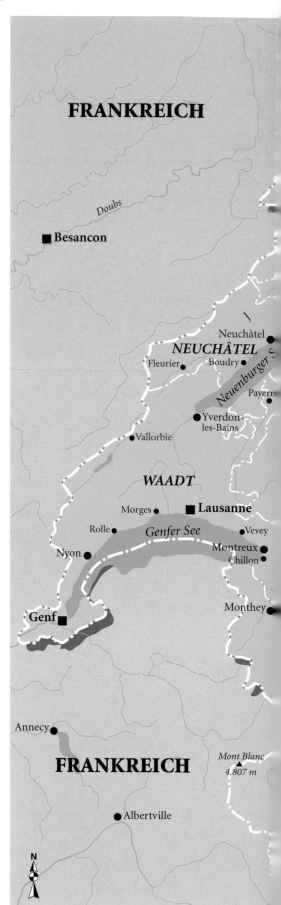

FRANKREICH

Doubs

■ Besancon

Neuchâtel

NEUCHÂTEL

Fleurier • • Boudry

Neuenburger

Payern

• Yverdon-les-Bains

• Vallorbie

WAADT

Morges • ■ Lausanne

Rolle • Genfer See • Vevey

Nyon • Montreux • Chillon

Genf ■

Monthey

Annecy •

Mont Blanc ▲ 4.807 m

FRANKREICH

• Albertville

N

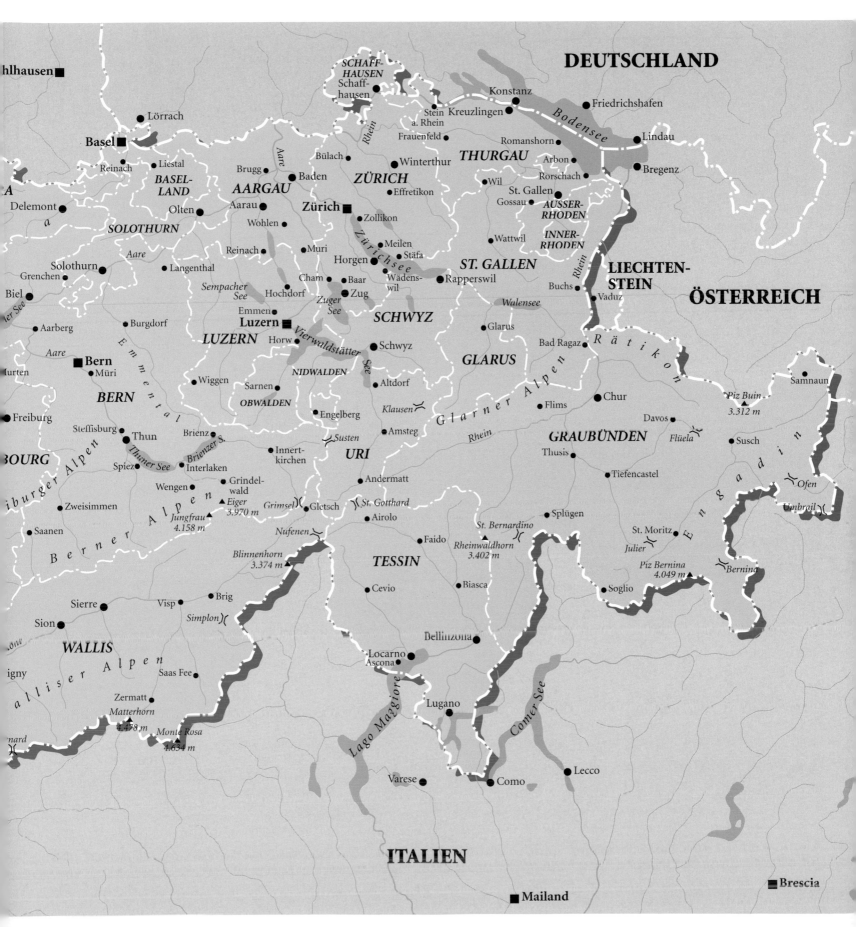

DEUTSCHLAND

hlhausen ■

SCHAFF-HAUSEN
Schaff-hausen

Konstanz
Friedrichshafen

Lörrach
Stein a. Rhein
Kreuzlingen
Bodensee
Lindau

Basel ■
Frauenfeld
Romanshorn
Arbon
Bregenz

Reinach
Liestal
BASEL-LAND
Brugg
Bülach
Winterthur
THURGAU
Rorschach

A
Baden
ZÜRICH
Wil
St. Gallen

Delemont
AARGAU
Aarau
Effretikon
Gossau
AUSSER-RHODEN

SOLOTHURN
Olten
Zürich ■
Zollikon

Wohlen
Meilen
INNER-RHODEN

Solothurn
Reinach
Muri
Wattwil

Grenchen
Langenthal
Horgen
Stäfa
ST. GALLEN

Biel
Cham
Baar
Wädens-wil
Rapperswil
Buchs
LIECHTEN-STEIN

Sempacher See
Hochdorf
Zug
Walensee
Vaduz
ÖSTERREICH

Aarberg
Burgdorf
Emmen
Zuger See
Glarus

Luzern ■
Zürichsee
Bad Ragaz
Rätikon

er See
SCHWYZ

Aarau
Horw
Vierwaldstätter See
Schwyz
GLARUS
Piz Buin 3.312 m
Samnaun

Bern ■
Müri
LUZERN
Chur

Aare
Wiggen
NIDWALDEN
Altdorf
Glarner Alpen
Flims
Davos

BERN
Sarnen
GRAUBÜNDEN
Flüela
Susch

Freiburg
OBWALDEN
Engelberg
Klausen
Amsteg
Rhein
Thusis

BOURG
Steffisburg
Thun
Brienz
Susten
Tiefencastel
Ofen

iburger Alpen
Thuner See
Brienzer S.
Innert-kirchen
URI
Andermatt

Spiez
Interlaken
Grindel-wald
Grimsel
Gletsch
St. Gotthard
Splügen
St. Moritz
Umbrail

Wengen
▲ Eiger 3.970 m
Airolo
St. Bernardino
Julier
Engadin

Zweisimmen
Jungfrau 4.158 m
Nufenen
Faido
Rheinwaldhorn 3.402 m
Piz Bernina 4.049 m ▲
Bernina

Saanen
Berner Alpen
Blinnenhorn 3.374 m
TESSIN

Sierre
Visp
Brig
Cevio
Biasca
Soglio

Sion
Simplon

WALLIS
alliser Alpen
Saas Fee

igny
Zermatt
Matterhorn 4.478 m
Monte Rosa 4.634 m
Bellinzona

nard
Locarno
Ascona
Lago Maggiore
Comer See

Lugano

Varese
Como
Lecco

ITALIEN

■ **Brescia**

■ **Mailand**

123

Credits

Photos:
*All photos are by Roland Gerth
with following exceptions: p. 74/75, p. 94/95
Robert Bösch, Oberägeri, Switzerland.*

Design
hoyerdesign grafik gmbh, Freiburg

Map
Fischer Kartografie, Fürstenfeldbruck

Text
*Introduction by Otto Merki
all other text by Marion Voigt*

Translation
Ruth Chitty, Schweppenhausen

*Die Deutsche Bibliothek – CIP catalogue record
Journey through Switzerland / Otto Merki, Marion
Voigt (authors). Roland Gerth (photographer) –
Würzburg: Verlagshaus Würzburg, 2000
ISBN 3-8003-0977-7*

*Printed in Germany
Reproductions by Artilitho, Trento
Printed by Konkordia Druck GmbH, Brühl
Bound by Josef Spinner Großbuchbinderei GmbH,
Ottersweier*
©2000 Verlagshaus Würzburg GmbH & Co. KG

ISBN 3-8003-0977-7